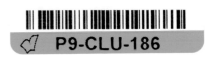

Call of the Coast *Art Colonies of New England*

Call of the Coast
Art Colonies of New England

Thomas Denenberg, Amy Kurtz Lansing, and Susan Danly

Portland Museum of Art, Maine
Florence Griswold Museum, Old Lyme, Connecticut

Distributed by
Yale University Press, New Haven and London

This catalog was published in conjunction with the exhibition *Call of the Coast: Art Colonies of New England*, co-organized by the Portland Museum of Art, Maine, and the Florence Griswold Museum, Old Lyme, Connecticut.

PORTLAND MUSEUM OF ART
June 25–October 12, 2009

FLORENCE GRISWOLD MUSEUM
October 24, 2009–January 31, 2010

Presentation of the exhibition at the Portland Museum of Art is made possible by Scott and Isabelle Black.

Media support has been provided by WCSH 6, the Portland Press Herald/Maine Sunday Telegram, and MPBN.

Edited by Rickie Harvey, Boston, Massachusetts

Designed by Charles Melcher, Margo Halverson, Alice Design Communication, Portland, Maine

Production by Sandra Klimt, Klimt Studio, Inc., Falmouth, Maine

Printed by Meridian Printing, East Greenwich, Rhode Island

Bound by Acme Bookbinding, Charlestown, Massachusetts

Set in ITC New Baskerville designed by John Baskerville, circa 1752. This version of Baskerville designed by George Jones for Linotype-Hell in 1930, and Frutiger designed by Adrian Frutiger in 1968.

Distributed by Yale University Press, New Haven and London
www.yalebooks.com

Library of Congress Control Number: 2008937653

ISBN: 978-0-300-15162-6

Cover: Clarence Chatterton, *Road to Ogunquit,* circa 1940, oil on Masonite, Portland Museum of Art

Frontispiece: Frank A. Bicknell, *Ogunquit, Maine,* undated, oil on artist's board, Florence Griswold Museum

Back cover: Charles Ebert, *Reflections, Old Lyme,* circa 1919, oil on canvas, Florence Griswold Museum

Contents

Josephine A. Townsend
Sarah Kent House, built by Rockwell Kent, 1936
Gelatin silver print postcard
Collections of the Maine Historic Preservation Commission

The Ghost of Rockwell Kent and Me

When I was first approached to write an introduction to *Call of the Coast: Art Colonies of New England*, I demurred. "I am the wrong person; I hate art colonies and wouldn't be caught dead working in one." Upon ending the conversation, I reflected. For over forty years I have lived and painted on Monhegan, the renowned "island art colony." But I didn't know it as an art colony, for as a child I would visit during the "off-season." When I moved to Monhegan, I soon learned that summer was a "different" story. Each day's mail boat brought yet another excited group of painters (serious and Sunday), trudging up Wharf Hill festooned with easels, paint boxes, brushes, etc. I grew to wish Monhegan were a destination for dentists, not painters. I suppose I was jealous and wanted the island for myself. "No artist's colony for me," I said. But therein lies my "conflict."

Rockwell Kent, along with Robert Henri and George Bellows, lived and painted on Monhegan in the early 1900s, carrying on the island's art-colony tradition. Kent, whose work I worshipped, later built the house in which I now live and work. I filled the house with his drawings and paintings. I read all of his books. In a sense, I tried to assimilate his life. Although our "shared time" on Monhegan was separated by many years, this assimilation became my art colony. This "community of painters": the ghost of Rockwell Kent and me.

Due to my recognition of this conflict, in an odd sense, I now identify with the painters represented in this exhibition, painters who worked in Old Lyme, Cos Cob, Ogunquit, and yes, Monhegan. They were onto something that I am, just now, beginning to recognize.

You, the viewer, will draw your own conclusions: Do art colonies work? Did these four communities produce inspired art? This exhibition, among other pleasures, explores those compelling questions.

Jamie Wyeth

Eric Hudson
Monhegan Harbor, circa 1898
Oil on canvas, 28 ⅛ x 34 1/16 inches
Portland Museum of Art

Acknowledgments

The genesis of *Call of the Coast: Art Colonies of New England* can be found in an article for *The Magazine Antiques* in 1999. A simple comparison between the artistic traditions of Old Lyme, Connecticut, and Ogunquit, Maine, the essay accompanied an exhibition at the National Museum of American Art called *Picturing Old New England*. The art-colony story, however, always seemed like an exhibition waiting to happen. Ten years later, the project comes to fruition at the Portland Museum of Art and the Florence Griswold Museum.

In Maine, Earle Shettleworth, our legendary state historian, provided a steady stream of references on both Ogunquit and Monhegan in his inimitable fashion. Nicholas Noyes, librarian at the Maine Historical Society, was helpful as ever. Richard Candee and Bob Chase both played local guide for a day of touring Ogunquit studios. At the Portland Museum of Art, colleagues Erin Damon, Sage Lewis, Ellie Vuilleumier, Lauren Silverson, Allyson Humphrey, Greg Welch, Kris Kenow, Karin Lundgren, Teresa Lagrange, and especially Monhegan resident Elena Murdock made the project happen. Jessica Routhier, formerly associate curator at the PMA and now director of the Saco Museum, Saco, Maine, wrote catalog entries and assisted in the initial organization of the exhibition. We are also indebted to the scholarship of past curators Jessica Nicoll and Aprile Gallant.

At the Florence Griswold Museum, Director Jeff Andersen deserves our heartfelt thanks for supporting the project from the very beginning. We also thank Amanda C. Burdan, the 2008–9 Catherine Fehrer Curatorial Fellow, who wrote catalog entries and provided curatorial assistance. Exhibition team members Tammi Flynn, David Rau, Janie Stanley, and Nicole Wholean have each been invaluable to the project's realization. In addition, we have relied on the curatorial files maintained by research associate Hedy Korst and on Hildegarde Cummings's scholarship on works in the Hartford Steam Boiler Collection. Jeff Andersen would also like to thank the following scholars, who have worked with the Florence Griswold Museum to increase knowledge about Lyme artists: Helen K. Fusscas, Harold Spencer, Bruce Chambers (deceased), Lisa Peters, Barbara MacAdam, Richard Boyle, Diane Fischer, Kathleen Burnside, and Carol Lowrey. We owe special thanks to Kathleen Motes Bennewitz and Anne Young, our colleagues at the Historical Society of the Town of Greenwich, for their gracious assistance with photographs of the Cos Cob colony.

We would also like to acknowledge the intellectual pathfinding of our friends and colleagues Jack Becker, Doreen Bolger, Tralice Bracy, Dona Brown, Donna Cassidy, Ned Cooke, Michael Culver, Ed Deci, Trevor Fairbrother, Tracie Felker, Pat Hills, Erica Hirshler, Susan Larkin, Carl Little, Judy Maxwell, Stephen May, Kevin Murphy, Stephen Nissenbaum, Bruce Robertson, Julia Rosenbaum, Roger Stein, Carol Troyen, and Bill Truettner.

This catalog is the work of many hands, including our ever-creative designers Margo Halverson and Charles Melcher of Alice Design Communication, publication manager Sandra Klimt, copy editor Rickie Harvey, and photographers Bernie Myers and Paul Mutino. We are indebted to Michelle Komie and Carmel Lyons at Yale University Press.

Last, but not least, we would like to thank our spouses, Amber Degn, Charles Lansing, and James O'Gorman—scholars and writers themselves, who put aside their work to read ours.

Thomas Denenberg
Amy Kurtz Lansing
Susan Danly

Introduction

THE COAST OF NEW ENGLAND, extraordinary for its geology and symbolic currency, has long attracted tourists and artists drawn to the primal drama of wave on rock or the soothing play of glasslike ocean greeting sandy shore. The coast is historic, animated in the public imagination by founding myths of the American colonies and legends of heroic maritime culture. It is timeless, populated by hardy individualists seemingly immune to the vicissitudes of change. It is literally on the verge of a sublime and capricious ocean. The coast can be quiescent, even genteel, a domestic-scale landscape of soft marshes, small islands, and sheltering coves imbued with restorative powers by tourists seeking relaxation. Above all, the coast of New England is multivalent. It is no one place or geographic feature but is built over time with layers of association by writers, artists, and storytellers. The New England coast, therefore, is as much cultural construction as natural phenomenon.

The nineteenth century brought about a sea change in the popular attitude toward the coast of New England. As industrialization, immigration, and urbanization propelled the United States into the modern era, the edge of the ocean shifted from being perceived as an economic resource to a therapeutic shelter. The Atlantic coast, once a zone of labor and commerce, became a haven for vacation. Hotels sprang up in the decade after the Civil War to serve a new middle class of managers and professionals enjoying leisure time with their families. Like-minded families colonized Nahant, York, Harpswell, Mount Desert, and other picturesque spots, re-pioneering life alongshore as part of a calendar prescribed by new patterns of life in the industrial age.

The call of the coast proved especially attractive to artists who placed their skills in service of the new tourist culture of summer. Seascapes—romantic visual dramas of sailing vessels tossed on the rocks or quiescent harbors brimming with commerce—enjoy a lineage that dates to the seventeenth century and remained in vogue for generations. In the course of the nineteenth century, however, from the sublime scenes of Thomas Cole, through the crystalline clarity of Martin John-

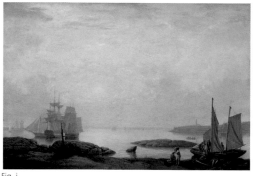

Fig. i

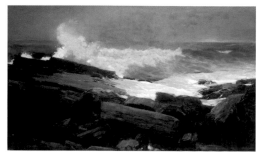

Fig. ii

son Heade and Fitz Henry Lane (fig. i), and on to paintings of place by Frederic Church, William Stanley Haseltine, Alfred Thompson Bricher, William Trost Richards, and Worthington Whittredge, images of the coast took on a nuanced and privileged importance in American visual culture. Winslow Homer, as responsible as any one American artist for orienting popular attention to the coast in the decades between the Civil War and the turn of the century, captured this new engagement with the ocean beginning with his depiction of bathers and strollers in the 1860s. In his 1882 move to Maine, Homer evolved into the father figure for a generation of painters who would come to eschew Victorian artistic convention and frame the coast as a modernist landscape (fig. ii).

Whereas Homer sought solitude—indeed his persona as the "hermit of Prouts Neck" is now the stuff of legend—the vast majority of painters, printmakers, and photographers who followed the tourist path to New England on railroads and steamship lines preferred company. Banding together for the purposes of camaraderie, creativity, and commerce, they founded coastal art colonies from Connecticut to Maine. This exhibition examines four such communities: Old Lyme, Cos Cob, Ogunquit, and Monhegan. In each spot, artists took pains to distinguish themselves from ordinary tourists by constructing a privileged relationship to each other, the local population, and the landscape. Influential figures such as Childe Hassam, John Henry Twachtman, Robert Henri, and Hamilton Easter Field at once fostered collegiality and inspired their students and followers to tackle the landscape with fresh, independent approaches.

Each colony also offered artists the opportunity to commune with the coast in its different guises, from rolling pastures by Long Island Sound to the elemental, rocky terrain of Maine. The resulting artworks suggest the atmosphere of their places of creation: flickering impressionist renderings conjure Connecticut's calm shore, while bolder textures and expressive forms announce Maine's rugged landscape. Works from New England's art colonies reflect this passage from south

to north, and with it, the modern idiom that emerged to articulate the region's powerful topography and lingering folk traditions.

The American fondness for art colonies can partly be traced to French antecedents between the 1870s and the 1890s.[1] During breaks from their studies in Paris, artists traveled to the countryside of Barbizon, Grez-sur-Loing, or Giverny to paint outdoors and to enjoy each other's companionship outside the competitive atmosphere of the ateliers. The rhythm of life in these colonies followed a pattern—staying at an inexpensive local inn, artists breakfasted together before dispersing into the countryside to sketch. Over lunch and dinner, they discussed their work, freely offering critiques and encouragement. After supper, they sang, played games, and shared in a general bonhomie. The coast proved to be an especially attractive subject (fig. iii). In Normandy and Brittany, where Americans founded colonies in Pont-Aven and Concarneau, they eschewed life at the beach and donned folk costumes, styling themselves simultaneously as natives and as bohemians sampling a taste of the preindustrialist past.[2] In Europe, as in America, traveling to a colony afforded the chance to savor local culture and even try on a new identity within a gathering of like-minded friends. Colony life became central to the American experience abroad, and artists sought to re-create similar communities back home.

Four American art colonies circumscribe the move to the coast. Old Lyme, Cos Cob, Ogunquit, and Monhegan, settled at different times by artists of greatly varying perspective, graphically illustrate the cultural work of life in such communities. There are certainly others; Provincetown and Gloucester come to mind immediately. Old Lyme, Cos Cob, Ogunquit, and Monhegan, however, serve as more than mere synecdoche. The essays and entries that follow are based on the institutional legacies of each colony. The works selected for the catalog and exhibition are drawn from the collections of the Portland Museum of Art and the Florence Griswold Museum and, therefore, encompass decades of collecting and interpreting.[3] Yet even within these parameters,

placing the art colonies of Connecticut and Maine in relation to each other reveals some surprising connections, ones created by the artist themselves when, at times, they circulated among these communities. *Call of the Coast: Art Colonies of New England* is an enduring memory of art making in Old Lyme, Cos Cob, Ogunquit, and Monhegan.

Thomas Denenberg
Amy Kurtz Lansing

[1] The definitive resource on European art colonies is Nina Lübbren, *Rural Artists' Colonies in Europe, 1870–1910* (New Brunswick, NJ: Rutgers University Press, 2001). See also Nina Lübbren, "Breakfast at Monet's: Giverny in the Context of European Art Colonies," in Katherine M. Bourguignon, ed., *Impressionist Giverny: A Colony of Artists, 1885–1915* (Giverny, France: Musée d'Art Américain/Terra Foundation for American Art; distributed by University of Chicago Press, 2007), 29–43. Another useful source is Michael Jacobs, *The Good and Simple Life: Artist Colonies in Europe and America* (Oxford: Phaidon Press, 1985).

[2] See Lübbren, *Rural Artists' Colonies*, 32.

[3] The Portland Museum of Art is home to the Hamilton Easter Field Collection, originally exhibited at the Barn Gallery in Ogunquit; and the Florence Griswold Museum is steward of the Hartford Steam Boiler Collection, a collection particularly strong in artists who worked in Old Lyme.

Fig. i. Fitz Henry Lane, *Castine Harbor*, 1852, oil on canvas. Portland Museum of Art, Maine. Bequest of Elizabeth Noyce.

Fig. ii. Winslow Homer, *Weatherbeaten*, 1894, oil on canvas. Portland Museum of Art, Maine. Bequest of Charles Shipman Payson.

Fig. iii. Eugène-Louis Boudin, *Beach Scene near Trouville*, 1886, oil on panel. Scott M. Black Collection.

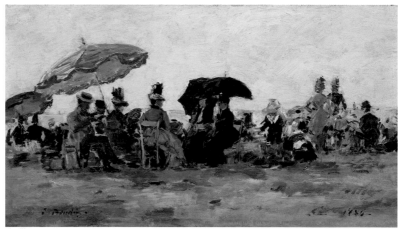
Fig. iii

Art Colonies of the Connecticut Coast

ARRIVING IN OLD LYME by train in 1899, artist Henry Ward Ranger spied France on the Connecticut shore. "It looks like Barbizon, the land of Millet. See the knarled [sic] oaks, the low rolling country. This land has been farmed and cultivated by men, and then allowed to revert back to the arms of mother nature. It is only waiting to be painted," he would later say.[1] At first blush, what attracted Ranger was the area's resemblance to the storied French village of Barbizon, an art colony at the edge of the forest of Fontainebleau, southeast of Paris. Part of this perceived charm, however, was the record of human presence Ranger saw inscribed in the landscape—an aura of history and tradition that would flavor paintings by members of the art colony Ranger went on to found in Old Lyme.

The quiet impress of man that Ranger admired about Barbizon and Old Lyme accounted for much of the appeal of the Connecticut coast to artists venturing out by train from New York. The village of Cos Cob, site of the state's other major art colony, offered century-old houses, a pocket-size harbor, and small farms—a far cry from the towering skyscrapers, vast waterfront, and bustling streets of the turn-of-the-century metropolis. The artists who painted in Old Lyme and Cos Cob delighted in the preindustrial atmosphere of these places, with their colonial architecture and cultivated landscape. Both locales gave evidence of long and happy habitation, of a landscape carefully tended across generations. Artists found these pastoral settings ideal for immersing themselves in nature through walks in the fields or along the shore, both op-

portunities to experience the outdoors on an intimate scale impossible in the city. The quiet voice of the Connecticut landscape drew artists into conversation with its subtle qualities, a discourse sustained through the establishment of colonies in Old Lyme and Cos Cob.

As early as the 1870s, artists began to colonize the town of Greenwich, of which Cos Cob is a part. The era in which the Cos Cob colony emerged coincided with the town's transformation from a farming and shipbuilding center to an upscale bedroom community for New York City. Greenwich offered both suburban convenience and rural simplicity, contributing to its development as a resort. Vacationers and artists alike took advantage of the railroad, which put outdoor recreation within easy reach of visitors from New York. Townspeople like the Holley family of Greenwich recognized the business opportunities that summer tourists presented and opened boardinghouses to cater to this crowd. The Holley House would become the nucleus of the Cos Cob art colony (fig. 1).[2] The presence of artists would prove an important factor in prolonging Cos Cob's survival as a coastal enclave with the waning of traditional industries such as shipbuilding.

The impressionist J. Alden Weir followed his father, the painter Robert W. Weir, to the Holley boardinghouse in Greenwich in the late 1870s. The younger Weir and his friend the artist John Henry Twachtman stayed there together in 1878 and 1879. Both painters formed a deep connection with the area, where they eventually bought their own homes—Weir in Branchville and Twachtman on Round Hill Road in Greenwich.

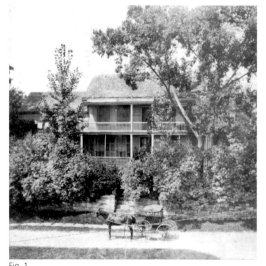
Fig. 1

The Ohio-born Twachtman had traveled extensively, circulating among the Midwest, Europe, and New York, but Connecticut offered him the opportunity to settle down with his family. His affection for the local landscape is confirmed by the fact that, for the decade following the purchase of his home in 1890, he drew the subject matter for his paintings almost exclusively from his own property; *Horseneck Falls, Greenwich, Connecticut* (plate 1), renders the brook on Twachtman's seventeen-acre farm, a motif he returned to many times. In *Barnyard* (plate 2), his daughter's simple act of feeding the family's chickens attains almost transcendent status as the fowl cluster around her white form. Both paintings depict the artist's domestic environment with the unhurried, contemplative tone of someone immersing himself in his surroundings. "I feel more and more contented with the isolation of country life," Twachtman wrote to Weir in the winter of 1891. "To be isolated is a fine thing and we are then nearer to nature. I can see how necessary it is to live always in the country— at all seasons of the year."[3] Twachtman would transmit his quiet appreciation of the landscape as a resident rather than a visitor to the other artists who eventually joined him in Connecticut.

Twachtman's presence in town helped provide the seed for the Cos Cob art colony. Despite his stated appreciation for rural solitude, his sociable nature and involvement with the Art Students League as a teacher drew other painters to him (fig. 2). Although they congregated at Twachtman's house, guests often spilled over into the nearby Holley House—now relocated to Cos Cob—which became known as a gathering spot for artists. During the two years before his premature death in 1902, Twachtman himself stayed at the Holley House, solidifying its reputation as the colony's focal point. The boardinghouse's location in working-class Cos Cob, as opposed to the more upscale precincts of Greenwich, suited its artist clientele, as did the proximity of colorful subjects such as the town's harbor and shipyard, which lay just across the road.

Summer classes, taught by Twachtman and Weir under the auspices of the Art Students League during the 1890s, brought a stream of artists to town. Art Students League pupils Ernest Lawson (plate 3), Charles Ebert, Mary Roberts Ebert, Daniel Putnam Brinley, and the Japanese artist and illustrator Genjiro Yeto all participated in the school's summer course. Clustered on Cos Cob's tiny working waterfront or on the shady grounds of the Holley House, these artists sketched outdoors and received biweekly critiques under an old apple tree.[4] Instructional methods at the summer school emphasized the development of a keen sensitivity to nature and an individuality of vision—traits that would continue to define the art made by Twachtman and Weir's former students. Shaped by the plurality of aesthetic outlooks represented by colony members like Yeto, and inspired by their teachers' receptivity to new ideas and techniques, these Cos Cob painters retained open minds about the evolution of American art. Charles Ebert, for example, experimented with bright colors borrowed from the Fauves in *Water's Edge,* his painting of Cos Cob's Palmer and Duff shipyard (fig. 3). And after the turn of the century, Brinley and other Cos Cob alumni formed the Association of American Painters and Sculptors, which organized the landmark Armory Show of 1913 that introduced modern European art to American audiences. Cos Cob artists' aesthetic independence and bohemian spirit distinguished them somewhat from the colony that formed later at Old Lyme, where members shared a more conservative and consistent outlook reinforced through their annual summer exhibitions.

The Cos Cob colony's reputation for encouraging experimentation benefited not only the younger artists who participated as students but more accomplished painters as well. The impressionist Theodore Robinson struggled to identify engaging subjects to paint in America between the long periods he spent in France. During visits to see Twachtman in Cos Cob, Robinson gradually developed a feel for the American landscape, eventually completing a series of paintings of the basin near the Riverside Yacht Club under different conditions of light and tide. Another artist to experiment at Cos Cob was Childe Hassam. During the summer of 1915, printmaker Kerr Eby made the etching press

Fig. 1. Unidentified photographer, the Holley House in Cos Cob, circa 1890, photograph. Courtesy William E. Finch Jr., Archives. The Historical Society of the Town of Greenwich.

Fig. 2. Unidentified photographer, John Henry Twachtman with an art student in Cos Cob, circa 1897, photograph. Courtesy William E. Finch Jr., Archives. The Historical Society of the Town of Greenwich.

Fig. 3. Charles Ebert, *Water's Edge*, undated, oil on canvas. Florence Griswold Museum.

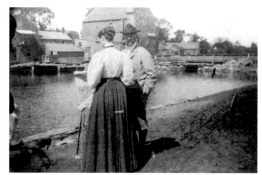

Fig. 2

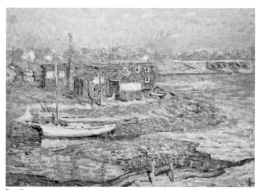

Fig. 3

in his Cos Cob studio available to Hassam, who delved seriously into the medium for the first time. Over the course of many visits to Cos Cob beginning in the mid-1890s, the artist worked in pastel and watercolor, adapting impressionist techniques to create sets of distinctive images in each medium. His Cos Cob pictures also reflect the diverse subject matter the village had to offer, from colonial-era houses to the immigrant-run waterfront businesses that gave it a slightly urban feel. Painted on a cigar box lid, *News Depot, Cos Cob* (fig. 4), depicts one such business, providing a glimpse not only of a favorite haunt of the artists, but of the day-to-day street life in the waterside town.

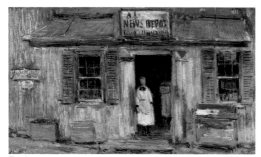
Fig. 4

Although the Cos Cob colony owed much of its existence to Twachtman, several other artists also made the town their home. Painter Leonard Ochtman boarded in Greenwich in 1890 and the next year moved there with his new wife, the artist Mina Fonda. Ochtman particularly liked Cos Cob's waterfront location, and by the mid-1890s, the couple had bought a house overlooking the Mianus River.[5] The artist ran his own summer classes in Cos Cob over the next two decades. His more tonal style of painting, seen in the soft greens of *Landscape* (plate 4), supplied students with an alternative to the impressionist style of Twachtman. Artist Clark Voorhees studied with Ochtman in 1896, the same year he first visited another coastal village that would soon attract landscape painters—Old Lyme.

Although Henry Ward Ranger's enthusiasm for Old Lyme's landscape crystallized during a stay in 1899, he was not the first artist to explore the eastern Connecticut coast: Reynolds Beal, Charles Davis (plate 5), and Robert Minor all painted along the sound in the 1890s, and in 1894, Joseph Boston led a summer school in Lyme on behalf of the Brooklyn Institute of Art.[6] Ranger had spent the summer of 1898 painting in East Lyme, Connecticut, a small town on Long Island Sound that had recently established itself as a seaside resort.[7] But, perhaps at the recommendation of Voorhees, who had bicycled through the area a couple of years before, Ranger made nearby Old Lyme his destination the next year in order to seek out the boarding-

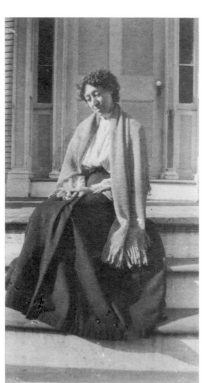
Fig. 5

house of Florence Griswold. Like those before him, Ranger identified Lyme as an ideal spot for artists to gather to paint outdoors. He invited several artist friends to join him in Old Lyme under "Miss Florence's" roof in the summer of 1900, and a colony was born.

Florence Griswold, an unmarried fifty-year-old woman and the only remaining member of an illustrious family whose ancestors included governors of Connecticut, had recently turned her home on Old Lyme's main street into a boardinghouse in order to support herself (fig. 5). The daughter of a ship captain, Griswold had been educated in literature, botany, music, and the fine arts. Her cultured background and natural talents as a conversationalist suited her for the role of gracious hostess, which she played for Ranger and the generations of artists who followed him to her doorstep. Her time-worn home (plate 6), built in 1817 along the banks of the Lieutenant River, became the epicenter of the Lyme Art Colony. There, she accommodated the artists' every need, converting barns into studio space, transforming the front hall into an informal gallery for the display and sale of her tenants' artwork, and allowing them to embellish the home's first floor with paintings on the walls and doors.

A great admirer of Dutch landscapes, Ranger appreciated the low-lying coastal terrain of Old Lyme, situated at the junction of the Connecticut River and Long Island Sound, with its tidal marshes and ever-changing light conditions. Muggy days, like that evoked in Walter Griffin's *Summer Haze, Old Lyme* (fig. 6), alternated with crisp autumns, bracing in their clarity of light. Just north of town, grassy farmland, mature second-growth forests, and gentle hills studded with granite ledges provided intriguing contrast to the flat terrain near the sound. As a journalist foreshadowed in 1876, "The variety of the landscape would drive an artist to distraction. It is a singular mixture of the wild and the tame, of the austere and the cheerful."[8] The Brooklyn Institute agreed, dedicating a page to Lyme in the circular for its summer art school that praised the town as "picturesque in outline, with wild ravines and rocky ledges, commanding fine views of the Connecticut River, Saybrook

Point, Long Island Sound, its islands, and the village—a wide range of varied and beautiful scenery."[9] The existence of diverse landscape within such a short distance proved irresistible to artists seeking a range of subjects on a single trip to the country.

While Twachtman saw the Connecticut coast as a place to isolate oneself in nature, Ranger viewed himself as the leader of a new school of American landscape painting centered in Old Lyme. His aesthetic preferences for old-master painting techniques, soft forms, and mellow, golden colors—a style often described as "tonalist"—dominated the colony's output in its first few years. The artist and his companions, who included Lewis Cohen, Louis Paul Dessar, William Henry Howe, Henry Rankin Poore, and Clark Voorhees, sought to capture the landscape's universal qualities. At the same time, Ranger conceived of these Connecticut scenes as inherently American, deeply invested with a history of toil dating to the first years of European settlement. Such landscapes reminded him of the settlers' "arduous conflict with soil and climate in their larger fight of conquering a living from the forest-grown and rock-ribbed hills," an association that "filled [him] with reverence and wonder."[10]

Between 1900 and 1903, the period during which Ranger was most involved with the colony, roughly thirty artists visited Old Lyme. Most were established in their careers and knew each other from New York or other art colonies like the one at Cos Cob, where Voorhees, Allen B. Talcott, and Will Howe Foote had all spent time. Their friendships provided an entrée into the Griswold House, where prospective tenants vetted new arrivals, and set the tone for colony life, which tended toward the conservative. The clubby atmosphere of what became known as the Holy House quickly fostered a sense of group identity that was bolstered as early as 1902 by the inauguration of annual summer art exhibitions at the town's library. Additionally, suppers served outdoors on the Griswold House veranda provided forums for lively conversation among colony members, who nicknamed their gatherings the Hot Air Club, as a nod to the venting of opinions about each other's work and art-world trends (fig. 7).

Entrusting their comfort to Miss Florence, as they called her, colony members were able to give themselves over to art during their stays in Old Lyme. As a satisfied Willard Metcalf observed, hers was a country retreat in which "every day is so in line with work."[11] Visits assumed a natural rhythm—a hearty breakfast each morning, followed by sketching en plein air in the fields or work in the studios dotting the Griswold House grounds, then dinner on the porch. When not at their easels, they took advantage of the seaside location to go boating, swimming, and fishing. Around the house, they pitched horseshoes, played baseball, orchestrated practical jokes, and staged elaborate costume parties and processions, reinforcing the bonds of friendship and refreshing themselves before their return to New York. The artists' high jinks occasionally attracted disapproval from town residents, who were shocked one day to see Hassam stroll to the post office in a flowered dressing gown and stovepipe hat rummaged from the Griswold House attic. However, Miss Florence's boundless goodwill and dedication to the artists' happiness helped smooth relationships with the community. At the end of her life, she could remark with satisfaction, "So you see, at first the artists adopted Lyme, then Lyme adopted the artists, and now, today, Lyme and art are synonymous."[12]

Inspired by their experiences at European art colonies such as Barbizon and Giverny during their student years, the artists of Old Lyme began a program of painting on the doors and walls of the Griswold boardinghouse, an effort that culminated in the dining room. There, over the fireplace, Henry Rankin Poore limned *The Fox Chase,* a fanciful painting that pokes gentle fun at the so-called School of Lyme. In the friezelike composition, artists working en plein air drop their brushes to race across the sandy terrain in pursuit of a fox. The painting's mood of boisterous fun and camaraderie and its emphasis on sketching outdoors convey the Lyme Art Colony's dual appeal to its members. Portraits were added to the composition between 1901 and 1905, reflecting the colony's growth as artists recruited one another to experience the Lyme landscape in an environment so conducive to

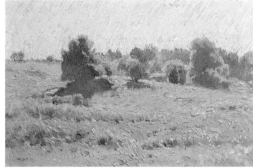
Fig. 6

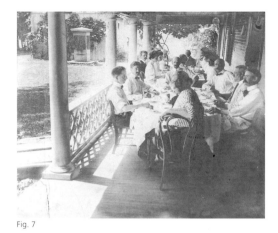
Fig. 7

Fig. 4. Frederick Childe Hassam, *News Depot, Cos Cob,* 1912, oil on cigar box lid. Florence Griswold Museum.

Fig. 5. Unidentified photographer. Florence Griswold on her front porch, circa 1895, photograph. Florence Griswold Museum. Lyme Historical Society Archives.

Fig. 6. Walter Griffin, *Summer Haze, Old Lyme,* undated, oil on artist's board. Florence Griswold Museum.

Fig. 7. Unidentified photographer, the Hot Air Club dining on the Griswold House porch, circa 1905, photograph. Florence Griswold Museum. Lyme Historical Society Archives.

work. Word spread about the paintings in the Griswold House, and the art colony's headquarters soon became a draw for tourists eager to see the artists and their work. One author wrote, "So many of the artists have left a visible impress upon [the house] in the way of a panel painted 'for remembrance,' that the old mansion has developed into a show-place of an altogether unique character. Every stranger within the gates of Lyme wants to see it—and to see it is to admire it."[13]

Students as well as established artists flocked to Old Lyme, often attracted by the presence of painters they admired (fig. 8). Summer classes hosted by the Art Students League of New York between 1902 and 1905 under the direction of Frank Vincent Du-Mond and Will Howe Foote brought dozens of pupils to town, while other painters taught privately to bolster their income. The presence of so many students annoyed some artists, who preferred to think that Old Lyme offered a retreat from teaching obligations. Painter Willard Metcalf made his preferences clear in a letter to Florence Griswold preceding his first visit to the colony in 1905. Upon hearing that a prospective pupil wanted to lodge near his teacher at the Griswold House, Metcalf wrote, "It is a somewhat delicate matter for me to speak of for Mr. B. is a charming man—but I should prefer not to have to see him at every meal—as he is *studying* art."[14] Perhaps because of her husband's prominence, an exception was made for Ellen Axson Wilson, the wife of future president Woodrow Wilson, who lodged with her family at the Griswold House during her art studies with DuMond between 1908 and 1911.

Women made up a significant percentage of the summer students, and the prevalence of their white-clad forms in the fields around town inspired resentment from the male artists, who had a low opinion of their talents. *Poor Little Bloticelli* (fig. 9), a dining-room panel from Metcalf's brush, pokes fun at one of these women—his own pupil, Lois Wilcox, who is shown painting outdoors. The cheeky title puns both on the name of the Italian Renaissance painter Sandro Botticelli and on the male artists' belief that the women were "blots" on the landscape. A picture postcard

of the Griswold House (captioned "Holy of Holies") addressed by one such female student to a friend painting in Ogunquit, Maine, demonstrates these amateurs' awareness of their unequal status: "This is where those who have 'arrived' stay—the students go to the Old Lyme Inn where a letter would reach me."[15] One of the few women to crack the colony's exclusive ranks was animal painter and Greenwich resident Matilda Browne (plate 7), whose acceptance into the Holy House clan is attested to by the panel she painted on the door to Florence Griswold's bedroom and her eventual inclusion in the mural *The Fox Chase*.[16]

Ranger disliked Old Lyme's growing popularity and, after 1903, decided to spend his summers in the quieter seaside village of Noank, Connecticut, where he bought a house. In his later paintings, such as *Long Point Marsh* of 1910 (plate 8), with its vast, cloud-filled sky, the shoreline plays a more prominent role than the fields and forests that initially attracted the artist to Old Lyme. The painting's brighter palette also hints at another transformation afoot in Old Lyme—its emergence as a colony for impressionists. The arrival in 1903 of the dynamic Childe Hassam, an artist known for his flickering brushwork and sun-infused canvases, inspired Old Lyme painters to experiment with high-key color and greater impasto. Just as Ranger presided over the colony in its early years, Hassam set the tone for its later phase, for which it is best known.

The Massachusetts-born Hassam is emblematic of artists drawn to the New England coast. A frequent summer traveler invigorated by outdoor painting sessions, Hassam sought both compelling scenery and a community of like-minded souls in several different resorts over the course of his career. In addition to Old Lyme, he spent productive periods on the remote Isles of Shoals (off the coast of New Hampshire); in the harbor town of Gloucester, Massachusetts; on New York's Long Island; and in Cos Cob—often seeking out the flower gardens or old-fashioned buildings that gave each spot its historic charm. During his first summer in Old Lyme, he wrote to fellow impressionist J. Alden Weir of Branchville, Connecticut: "We are up here in another old

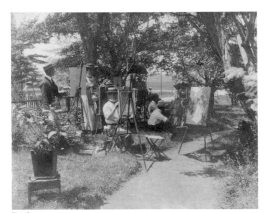

Fig. 8

Fig. 9

corner of Connecticut, and it is very much like your country. There are some very large oaks and chestnuts and many fine hedges. Lyme, or Old Lyme as it is usually called, is at the mouth of the Connecticut River and it really is a pretty fine old town."[17] *The Ledges, October in Old Lyme, Connecticut* (plate 9), affirms Hassam's admiration for the area's forests and distinctive rock formations, as well as his dedication to recording the autumn sun's dazzling play over the stones and leaves. But what appealed to him most was the colonial architecture that made Old Lyme a "pretty fine old town"—particularly the whitewashed First Congregational Church down the shady main street from the Griswold House. Hassam depicted the church numerous times in oil, pastel, and etchings, transforming it into a New England icon. His emphasis on the play of light over the building's solid architecture infuses these images with the romance of New England's past and underscores the theme of endurance in the face of change.

Not only Hassam gravitated toward Lyme's old-fashioned atmosphere. Many of the artists, including Hassam and Willard Metcalf, came from old New England families and venerated the architectural survivals from their ancestors' era. Metcalf's *May Night* of 1906 (Corcoran Gallery of Art), a moonlit portrait of Florence Griswold's house that quickly became the artist's most acclaimed painting, epitomizes this reverence for the colonial past. These artists developed a repertoire of historic subjects that became synonymous with the Lyme colony—from the church to the quaint, wooden Bow Bridge over the Lieutenant River to the stately homes lining the main street—which appear in paintings by Everett Warner (plate 10), Harry Hoffman (see plate 6), and Charles Ebert (plate 11).

In selecting motifs, Old Lyme artists favored reminders of an earlier era over acknowledgments of the present.[18] Following the destruction of the Congregational Church by fire in 1907, they even pledged profits from their summer exhibition toward rebuilding a near replica of the structure. By then, the church had become such a signature of Old Lyme that the colony's artists could little afford to lose it as a subject for their paintings.

As early as 1907, critics recognized that the shared subject matter of these works made Old Lyme recognizable as a brand. The successful sale of numerous Lyme subjects by Willard Metcalf during a single exhibition caused one author to compare Lyme landscapes with the booming fortunes of Standard Oil.[19] Each year, the arrival of more artists to record the town's genteel, old-fashioned scenery only burnished the value of Old Lyme's "stock." Any anxieties that the town's conservative inhabitants may have harbored that the burgeoning art colony would diminish Old Lyme's historic character faded as the painters enshrined its landmarks on canvas.

Pleased with their surroundings and the blossoming art community, many Lyme Art Colony members purchased homes in the area. The ease of returning throughout the year—whether to one's own house or as the beneficiary of Florence Griswold's hospitality—fostered a special attention to the changing seasons. In winter, Lyme Art Colony painters continued to work outdoors, often in specially built studio wagons heated by woodstoves and pulled across the fields by oxen (fig. 10). Snow-covered landscapes, like those depicted in Clark Voorhees's *December Moonrise* (plate 12) or Everett Warner's *Winter on the Lieutenant River* (plate 13), allowed these Connecticut impressionists to explore blue, violet, and mauve tints—a cool counterpoint to the golden tones earlier favored by Ranger.

Impressionist Willard Metcalf, a naturalist who combed the fields and forests of Old Lyme for bird eggs and butterflies, harbored a special affection for the nuances of each season. His *Dogwood Blossoms* (plate 14), painted in Old Lyme in 1906, exudes the fresh greens and tremulous leaves of early spring. William Chadwick and Edward Rook (plate 15) were among the many artists to record the ephemeral splendors of mountain laurel—Connecticut's state flower—blooming along the Lieutenant River each June. And, from his home on Grassy Hill in Lyme (fig. 11), Frank Vincent DuMond rendered the New England landscape's fall raiment of brilliant leaves fluttering over stone walls, as did Ernest Albert (plate 16).

The atmospheric clarity DuMond cap-

Fig. 8. Unidentified photographer, outdoor painting class, Lyme Summer School of Art, circa 1904, photograph. Florence Griswold Museum. Lyme Historical Society Archives.

Fig. 9. Willard Leroy Metcalf, *Poor Little Bloticelli*, 1907, oil on wood panel. Florence Griswold Museum. Gift of the artist.

Fig. 10. Unidentified photographer, artist Benjamin Eggleston with portable studio, undated, photograph. Florence Griswold Museum. Lyme Historical Society Archives.

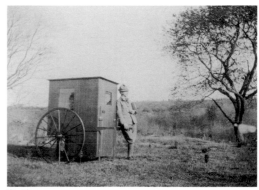

Fig. 10

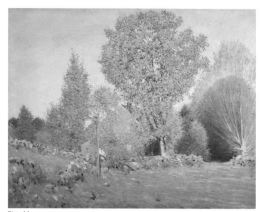

Fig. 11

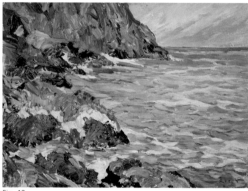

Fig. 12

Fig. 11. Frank Vincent DuMond, *Grassy Hill*, 1920, oil on canvas. Florence Griswold Museum.

Fig. 12. Charles Ebert, *Foot of the Cliffs*, circa 1929, oil on artist's board. Florence Griswold Museum.

Fig. 13. Charles Ebert, *Reflections, Old Lyme*, circa 1919, oil on canvas. Florence Griswold Museum.

tures could be elusive in Old Lyme during the summer; Griswold boardinghouse denizens nicknamed one of the rowboats moored on the banks of the Lieutenant River the Prickly Heat, a nod to the marsh-side town's warm-weather discomforts. In search of cooler air, Lyme Art Colony painters often made side trips to Monhegan and Ogunquit in Maine during the month of August, returning to Connecticut as fall approached.[20] Charles Ebert and Mary Roberts Ebert alternated between their Connecticut homes (first in Cos Cob and later in Old Lyme) and the island of Monhegan, where the husband-and-wife artists painted part of each summer beginning in 1909. A comparison between his robust *Foot of the Cliffs* (fig. 12) and the thinly painted *Reflections, Old Lyme* (fig. 13), reinforces the qualities artists appreciated about the Connecticut coast; Monhegan offered sweeping vistas, dramatic cliffs, and craggy textures, while Old Lyme's eddying waterways provided a quiet mirror for autumnal foliage, old houses, and gentle hillsides.

By 1910, in both Old Lyme and Cos Cob, artists had settled into their respective communities. Although the Florence Griswold House and Holley House remained social centers, artists in both places created new institutions to reflect their enduring associations with each town. Painters in Old Lyme had held annual summer exhibitions of their work in the local library as early as 1902, an idea that spread to other New England art colonies, such as Cos Cob and Ogunquit. In 1914, colony members incorporated the Lyme Art Association to create a permanent place for the display and sale of their works. Three years later they purchased from Florence Griswold a parcel of land adjacent to her house and erected a gallery, which opened in 1921, with her as manager. In Cos Cob, painter Elmer MacRae held his first solo exhibition in the Holley House in 1908. Its success as a venue for selling artists' work inspired the creation of the Greenwich Society of Artists, which incorporated in 1912. The emergence of artist-run societies in these colonies broadened the parameters of membership in each group—association with the colony no longer depended on whether the artists lived

together but rather on contributing to exhibitions, which now took place year-round. Emil Carlsen typifies this trend. He had painted in Cos Cob since the 1890s without ever becoming a permanent resident but he exhibited with the Greenwich Society of Artists beginning in 1919 (plate 17).

Although artists continued to live and work in colonies along the Connecticut coast, both Cos Cob and Lyme waned in prominence following World War I. The ease of travel to more exotic locales and the aesthetic shift toward modernism contributed toward diminished interest in the colonies and the art created by their members. In Old Lyme, the number of boarders at the Griswold House flagged in the 1920s and 1930s. The remaining artists looked after the building and Miss Florence, providing her with a measure of security in her final years. In 1936 they incorporated the Florence Griswold Association to care for her and, after her death, purchased her home, helping to enshrine the colony in historical memory through a house museum first opened to the public in 1947.

Amy Kurtz Lansing

[1] Henry Ward Ranger, as quoted in the *New Haven Morning Journal and Courier*, July 5, 1907. The artist echoed these sentiments in his book *Art-Talks with Ranger*, saying, "As for me, a landscape to be paintable must be *humanised* [sic]. All landscapes that have been well painted are those in which the painter feels the influence of the hand of man and generations of labour." Ralcy Husted Bell, *Art-Talks with Ranger* (New York: G. P. Putnam's Sons, 1914), 81.

[2] The Holleys originally ran a boardinghouse on their farm, but eventually lost it to foreclosure. In 1882 they relocated to a smaller building in Cos Cob, where they operated the boardinghouse known as the Holley House. For details on the Cos Cob colony's emergence from the Holley family's boardinghouses, see Susan Larkin's definitive account of the colony: Susan G. Larkin, *The Cos Cob Art Colony: Impressionists on the Connecticut Shore* (New York and New Haven, CT: National Academy of Design and Yale University Press, 2001), 13–15.

[3] Twachtman to J. Alden Weir, letter postmarked December 16, 1891, in *The Life and Letters of J. Alden Weir*, Dorothy Weir Young and ed. Lawrence W. Chisolm (New Haven, CT: Yale University Press, 1960), 189–90.

[4] Larkin, *Cos Cob Art Colony*, 35.

[5] Ibid., 90.

[6] Davis and Minor owned homes in eastern Connecticut—Davis in Mystic, where he settled in 1892, and Minor in Waterford.

[7] On Ranger's introduction to Old Lyme, see Jack Becker, *Henry Ward Ranger and the Humanized Landscape* (Old Lyme, CT: Florence Griswold Museum, 1999), 15–16.

[8] Martha J. Lamb, "Lyme, A Chapter of American Genealogy," *Harper's New Monthly Magazine*, February 1876, 327.

[9] Circular for "Summer School of Art Under the Auspices of the Art Department of the Brooklyn Institute of Arts and Sciences," 1894. Artist files, Florence Griswold Museum.

[10] Ranger as quoted in Bell, *Art-Talks with Ranger*, 80.

[11] Willard Metcalf to Florence Griswold, August 20, 1907, Florence Griswold Papers, Lyme Historical Society Archives, Florence Griswold Museum.

[12] Griswold as quoted in *New Era* (Deep River, CT), July 16, 1937, np.

[13] H. S. Adams, "Lyme—A Country Life Community," *Country Life in America*, April 1914, 47.

[14] Willard L. Metcalf to Florence Griswold, May 4, 1905. Florence Griswold Papers, Lyme Historical Society Archives, Florence Griswold Museum.

[15] C.M.P., Lyme, Connecticut, to Miss Bertha S. Shephard, Ogunquit, Maine, postcard postmarked August 4, 18[?]9, Lyme Historical Society Archives, Florence Griswold Museum.

[16] Early souvenir postcards illustrating *The Fox Chase* show that Browne was not among the original group of artists depicted in the painting. Based on the style of her clothing and the dates of subsequent postcards, Browne appears to have been added sometime after 1920.

[17] Hassam to Weir, letter dated July 17, 1903, in *Childe Hassam in Connecticut*, Kathleen M. Burnside (Old Lyme, CT: Florence Griswold Museum, 1987), 5.

[18] Old Lyme underwent significant modernizations during the colony's height, including the installation of streetcars, the introduction of electricity and telephones, and the construction of a vast railroad bridge over the Connecticut River. These changes seldom register in Lyme Art Colony paintings.

[19] Lillian Baynes Griffin, "Art Colony at Old Lyme Expands," *Hartford Courant*, July 4, 1907, 2.

[20] The circuit between Maine and Connecticut was well traveled by Old Lyme painters. The *New Era* newspaper, published in Deep River, Connecticut, just across the river from Old Lyme, regularly mentions the departure and return of artists such as Arthur Heming and Edward Rook for and from Ogunquit and Monhegan. See, for example, *New Era* (Deep River, CT), August 20, 1909.

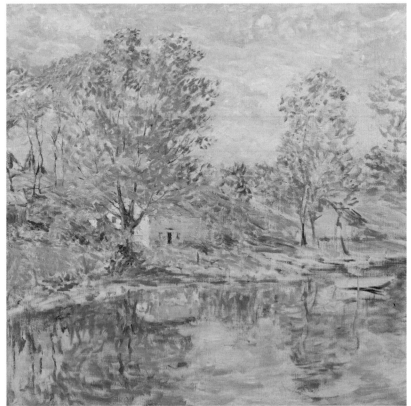

Fig. 13

Entries

Connecticut

John Henry Twachtman (1853–1902)

Plate 1
Horseneck Falls, Greenwich, Connecticut,
circa 1890–1900
Oil on canvas, 25 ¼ x 25 ¼ inches
Florence Griswold Museum

Plate 2
Barnyard, circa 1890–1900
Oil on canvas, 30 ¼ x 25 ⅛ inches
Florence Griswold Museum

During the last decade of the nineteenth century, John Twachtman focused his attention on painting scenes of his farm in Greenwich, Connecticut. The Horseneck Brook, which ran through the property, as well as its falls and the hemlock pool it fed, appeared frequently in his work during this productive period. Work from this phase is markedly different from his paintings of the previous two decades, when he was decidedly under the influence of Frank Duveneck, creating tonalist-inspired images with muted colors and vigorous brushwork. In Greenwich his painterly impasto and high-key color schemes visually indicate his coming to terms with impressionism, a style he resisted for years.

The roughly handled earth tones and whites of *Barnyard* reinforce the connection between nature and domestic life in the country. Twachtman's wife, the artist Martha Scudder, is rendered monochromatically, in a variation of the warm brown used for the roosters in the foreground. His daughter, a blur of white like the doves fluttering nearby, anchors the painting at its center. The effect of sunlight breaking through the overhead trees activates the barnyard itself, as well as the chalky white coop and vine-laden garden.

ACB

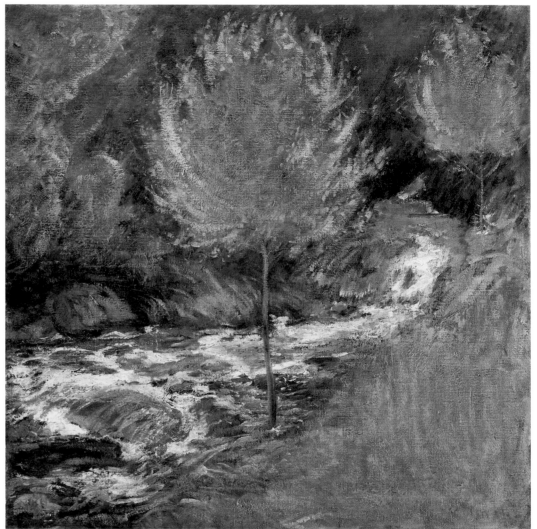

Plate 1

References:

Eleanor Jones Harvey, *An Impressionist Sensibility: The Halff Collection* (Washington, DC: Smithsonian American Art Museum, 2006).

Susan G. Larkin, *The Cos Cob Art Colony: Impressionists on the Connecticut Shore* (New York and New Haven, CT: National Academy of Design and Yale University Press, 2001).

Susan G. Larkin, "On Home Ground: John Twachtman and the Familiar Landscape," *American Art Journal* 1, no. 2 (1998): 53–85.

Lisa N. Peters, *John Henry Twachtman: An American Impressionist* (Atlanta, GA: High Museum of Art, 1999).

Lisa N. Peters, "'Spiritualized Naturalism': The Tonal-Impressionist Art of J. Alden Weir and John H. Twachtman," in *The Poetic Vision: American Tonalism*, ed. Ralph Sessions (New York: Spanierman Gallery, 2005).

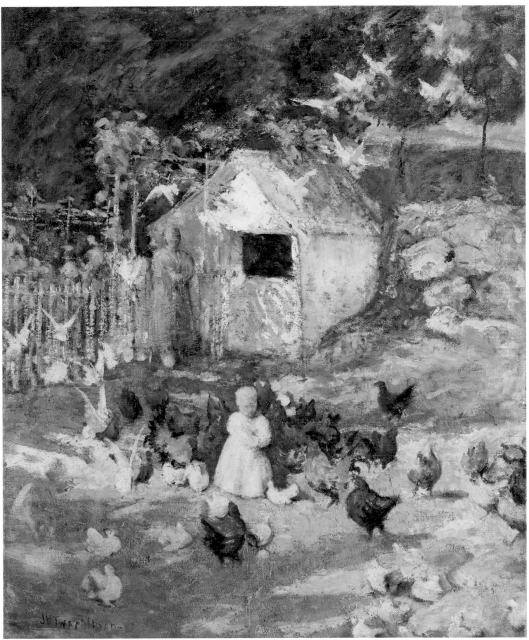

Plate 2

Ernest Lawson (1873–1939)

Plate 3

Connecticut Landscape, circa 1902–4
Oil on canvas, 24 ⅛ x 24 ⅛ inches
Florence Griswold Museum

Prior to his involvement in the American independent group known as the Eight, Ernest Lawson was a struggling American impressionist. As a young man at the Art Students League in the early 1890s, Lawson came under the influence of the popular teacher John Twachtman, who lived in Greenwich, Connecticut, at the time. Twachtman also taught, less formally, at the art colony developing in Cos Cob and lured Lawson there in 1892. When he first started, fellow colonist J. Alden Weir exclaimed, "By Jove, I have never seen so bad a picture," upon viewing one of Lawson's early landscapes (Larkin, 38).

From that base assessment, Lawson continued to improve, studying art abroad at the Académie Julian before returning again to paint landscapes in Connecticut. Lawson's distinctive impressionist brushstroke is readily apparent in *Connecticut Landscape.* He placed strongly contrasting strokes side by side, challenging the viewer to blend them optically. The effect of shimmering movement, or "crushed jewels," as one critic called it, makes it difficult to discern the distinction between sparkling water and sunlight glinting off the foreground grasses. This vibrating sensation is also seen in the late work of the French impressionist Alfred Sisley, whom Lawson met while studying abroad.

ACB

References:

Adeline Lee Karpiscak, *Ernest Lawson, 1873–1939* (Tucson: University of Arizona Museum of Art, 1979).

Susan G. Larkin, *The Cos Cob Art Colony: Impressionists on the Connecticut Shore* (New York and New Haven, CT: National Academy of Design and Yale University Press, 2001).

Valerie Ann Leeds, *Ernest Lawson* (Santa Fe, NM: Gerald Peters Gallery, 2000).

F. Newlin Price, "Lawson, of the 'Crushed Jewels,'" *International Studio* 78 (February 1924): 370.

Ameen Rihani, "Landscape Painting in America: Ernest Lawson," *International Studio* 72 (February 1921): cxiv–vii.

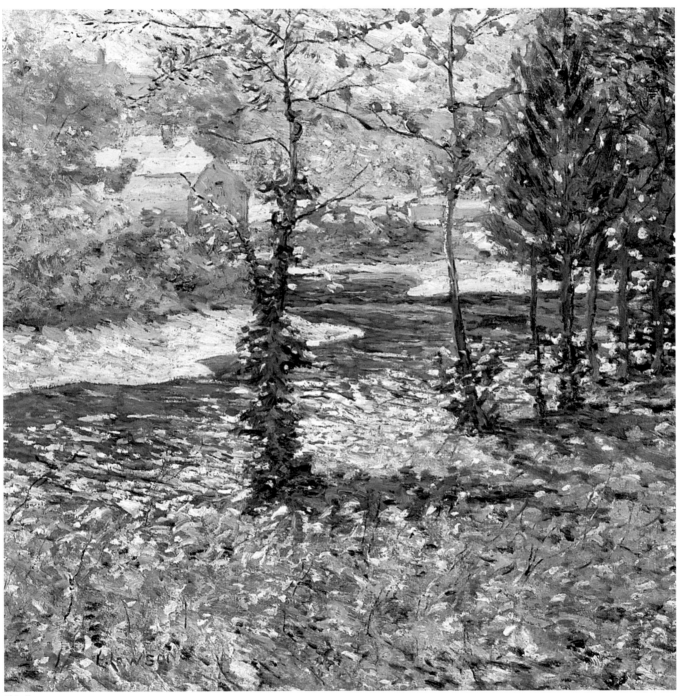

Plate 3

Leonard Ochtman (1854–1934)

Plate 4
Landscape, undated
Oil on canvas, 12 x 16 inches
Florence Griswold Museum

When Leonard Ochtman and his wife, Mina Fonda Ochtman, decided to make their new home in the Greenwich, Connecticut, area, they joined a league of artists who frequented the art colonies of coastal New England. Ochtman's vision of the Connecticut landscape took shape in Cos Cob as he negotiated a style between the Barbizon, tonalist, and impressionist approaches. The area was already a choice location for artists such as J. Alden Weir and John Twachtman, who found its proximity to New York City as well as the scenic views of Long Island Sound and the Mianus River appealing.

Ochtman flourished in the cultural climate of art colonies like Cos Cob and Woodstock, New York. As a young man in Albany his formal training in painting was limited, bypassing the art schools and academies in America during his youth. His formative trip to Europe, in 1885, introduced him to the plein-air style of painting commonly practiced by artists on their summer sojourns out of Europe's art centers. He progressed rapidly toward his individual style once he came in closer contact with colleagues, whether in New York City or the more pastoral settings of rural New England.

ACB

References:

Susan G. Larkin, *The Cos Cob Art Colony: Impressionists on the Connecticut Shore* (New York and New Haven, CT: National Gallery of Design and Yale University Press, 2001).

Susan G. Larkin, *The Ochtmans of Cos Cob* (Greenwich, CT: Bruce Museum, 1989).

"Mr. and Mrs.": Connecticut Impressionists, exhibition catalog (Old Lyme, CT: Old Lyme Impressionists, 1983).

Ralph Sessions, ed., *The Poetic Vision: American Tonalism* (New York: Spanierman Gallery, 2005).

Diana Dimodica Sweet, "Leonard Ochtman: Interpreter of Nature's Tonal Hues and Moods of Lyrical Sentiment," *Illuminator* (Summer 1981): 12–16.

Plate 4

Charles Harold Davis (1856–1933)

Plate 5

Afternoon Clouds, undated
Oil on canvas, 13 x 16 ⅛ inches
Florence Griswold Museum

Charles Harold Davis quite literally felt called to the coast. In the 1880s he was an American artist well established in the French art world, studying at the Académie Julian, exhibiting at the Paris Salon, and making frequent trips to paint in art colonies at Barbizon and Fleury. His early career work exemplified tonalist landscape painting even as impressionism was gaining strength as a movement. In 1890 Davis moved his French wife and family back to the United States after a decade abroad. In searching out just the right location to continue his landscape career, Davis considered the geography, topography, and climate of the New England region, finally settling on Mystic, Connecticut. He spent the remaining forty years of his life at the nexus of the Mystic River and Long Island Sound, painting more than nine hundred views of coast, uplands, and most of all, atmospheric effects.

Davis's style gradually shifted over the course of his career, becoming more influenced by impressionism back in the United States than it was while in France. He became the leading artist of the burgeoning Mystic Art Colony, instrumental in founding the Mystic Art Association, in 1913. As his reputation grew in America—he won innumerable prizes and awards—students sought his advice on landscape technique, in particular, the painting of clouds, of which he was a master. Attempting to convey his passion for clouds in a 1909 article in *Palette and Bench,* Davis wrote: "One must *feel* them and struggle. If you do not love skies sufficiently to observe and study them as you would the figure or the other elements of landscape, put up your horizon line or otherwise eliminate the sky as an important feature of your work, for you cannot fill large spaces with interest without earnest, patient, loving study in this direction, any more than in any other."

ACB

References:

David Adams Cleveland, *Intimate Landscapes: Charles Warren Eaton and the Tonalist Movement in American Art, 1880–1920* (Groton, MA: DeMenil Gallery at Groton School, 2004).

Charles H. Davis, "A Study of Clouds," *Palette and Bench* 1 (September 1909): 261–62.

Charles Harold Davis, N.A., 1856–1933, exhibition catalog (Mystic, CT: Mystic Art Association, 1982).

The Intimate Landscape of Charles Harold Davis, exhibition catalog (New York: Gerald Peters Gallery, 2007).

H. Barbara Weinberg and Susan G. Larkin, *American Impressionists Abroad and at Home: Paintings from the Metropolitan Museum of Art* (New York: American Federation of Arts, 2000).

Plate 5

Harry L. Hoffman (1871–1964)

Plate 6
View of the Griswold House, 1908
Oil on pressed board, 16 x 12 inches
Florence Griswold Museum

Like Willard Metcalf, his mentor in Old Lyme, Harry Hoffman was drawn to the neoclassical facade of the Griswold House. For each artist, this down-at-the-heels mansion was a place full of remembered pleasures and personal associations. Hoffman wisely chose not to echo Metcalf's 1906 *May Night* (Corcoran Gallery of Art), a romantic, moonlit view of the temple-like house that brought Metcalf great acclaim. Rather, Hoffman strikes his own ground with a perspective that connects the house more closely to the everyday world. A veil of scraggly shrubs partially screens the portico and undercuts the formality of the facade. The house appears well worn, as if lived in for generations by a family whose values revolve around continuity and stability. That stability was tenuous at times, and late in Florence Griswold's life, Hoffman helped by easing some of her financial burdens.

Hoffman's traditional art training at Yale and in Paris yielded to a lifelong devotion to impressionism at Old Lyme, but he was open to experimentation. By 1916 he was employing a glass-bottomed bucket for painting underwater sea life. The resulting paintings were so innovative that he was asked to accompany scientists to the Galapagos Islands and Bermuda.

JWA

References:

Jeffrey W. Andersen, *Harry L. Hoffman: A World of Color* (Old Lyme, CT: Florence Griswold Museum, 1988).

Bruce W. Chambers, *May Night: Willard Metcalf at Old Lyme* (Old Lyme, CT: Florence Griswold Museum, 2005).

Plate 6

Matilda Browne (1869–1947)

Plate 7
Saltbox by Moonlight, undated
Oil on canvas, 14 x 10 inches
Florence Griswold Museum

Matilda Browne found her way to Old Lyme in 1905, having already earned a prestigious artistic reputation. Unlike other women artists who visited Old Lyme during the summer months, Browne was not considered to be an amateur or a trifling student. Her credentials equaled the accomplishments of her male counterparts, including study at the Académie Julian, in Paris, exhibitions at the annual Parisian Salon and at the Art Institute of Chicago, and prizes from the National Academy of Design and the Chicago World's Fair. Her fellow art colonists in Old Lyme bestowed a local honor upon her when she was asked to paint a door panel at the Griswold House, headquarters to the most well known of the Old Lyme painters. Browne's acceptance by these male artists may also owe something to the fact that she knew many of them from Cos Cob and Greenwich, where she lived year-round beginning in the mid-1890s.

Browne gained notoriety throughout her career not just because of her gender, but also for being somewhat of a child prodigy. She studied first with Thomas Moran, her family's neighbor in Newark, New Jersey, at the age of nine. Although Moran was a landscape artist, Browne began by painting floral still lifes, a more common subject for women. At age twelve she exhibited one of these floral studies at the National Academy of Design. She eventually discovered her true expertise in the field of animal painting, earning her the nickname "the American Rosa Bonheur." *Saltbox by Moonlight* reveals the enduring aspect of New England's colonial architecture, another subject favored by Browne.

ACB

References:

Jeffrey Andersen, *Old Lyme: The American Barbizon* (Old Lyme, CT: Florence Griswold Museum, 1982).

Jeffrey Andersen and Hildegard Cummings, *The American Artist in Connecticut: The Legacy of the Hartford Steam Boiler Collection* (Old Lyme, CT: Florence Griswold Museum, 2002).

Plate 7

Henry Ward Ranger (1858–1916)

Plate 8
Long Point Marsh, 1910
Oil on canvas, 28 x 36 inches
Florence Griswold Museum

Remembered today as the founder of the Lyme Art Colony in 1899, the tonalist Henry Ward Ranger was an extraordinary figure, with all the facets of a rough-cut jewel. He was, in equal measure, an artist who enjoyed extensive success in his own day (the *New York Times* referred to him as "the dean of American landscape"), an entertaining if dogmatic writer (one friend said his views were "fixed and seldom changed"), a talented musician, a charismatic leader of other artists, and a tastemaker whose opinions collectors valued. Though conservative in his art, Ranger was progressive in business and in philanthropy. Ranger led efforts to build the first studio cooperative in New York, and upon his death in 1916, his will established the Ranger Fund, which over the ensuing decades enabled museums to purchase hundreds of paintings by contemporary artists.

Ranger's leadership in Old Lyme was short lived, and by 1904 he was based in nearby Noank, Connecticut, a fishing village with a working harbor on the Mystic River. Mason's Island, just across an inlet, became a favorite subject for its dense woods and marshy waters. *Long Point Marsh* depicts the region's grassy marshes under a cloud-filled sky. With its low horizon, impressionist palette, and attention to cloud forms, it shows Ranger's awareness of and admiration for the work of Charles Harold Davis, the Mystic-based landscape painter whose *Afternoon Clouds* (see plate 5) can be found in this exhibition.

JWA

References:

Jeffrey Andersen, *Old Lyme: The American Barbizon* (Old Lyme, CT: Florence Griswold Museum, 1982).

Jack Becker, *Henry Ward Ranger and the Humanized Landscape* (Old Lyme, CT: Florence Griswold Museum, 1999).

Ralcy Husted Bell, *Art-Talks with Ranger* (New York: G. P. Putnam's Sons, 1914).

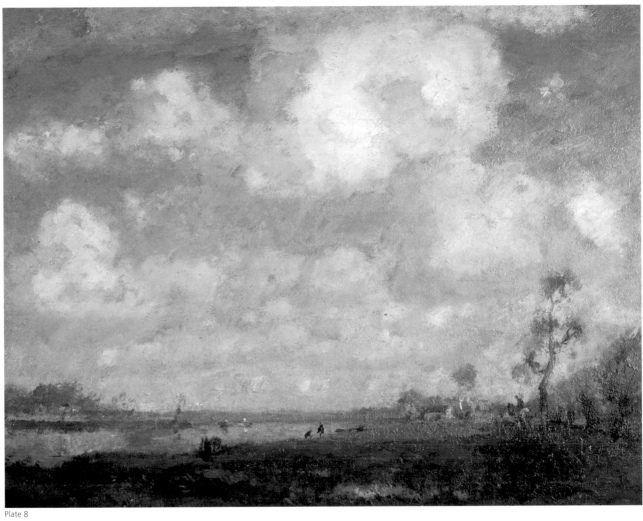

Plate 8

Frederick Childe Hassam (1859–1935)

Plate 9
The Ledges, October in Old Lyme, Connecticut, 1907
Oil on canvas, 18 x 18 inches
Florence Griswold Museum

Although affiliated with a number of New England art colonies, Childe Hassam had, perhaps, his greatest impact on the group at Old Lyme. Beginning in 1903, he regularly visited Florence Griswold's boardinghouse on Lyme Street and turned many of the artists in residence there from the tonalist to the impressionist style. An established American painter, Hassam had already helped to found the group known as the Ten in New York, along with John H. Twachtman and J. Alden Weir. All three painted together at Cos Cob. At Miss Florence's, Hassam painted several of the renowned dining-room panels and is memorialized in the house's overmantel representation of the art colonists, entitled *The Fox Chase,* where he is depicted as working bare chested en plein air. He called Old Lyme "just the place for high thinking and low living" and took pleasure in shaking up the townsfolk with his eccentric behavior.

The Ledges, October in Old Lyme, Connecticut, captures a well-known feature of the Lyme landscape that anyone who visited would instantly recognize. The granite ledges and virtual walls of rock with their curiously tenacious trees are common sights around Lyme. The repetitive verticals of the trunks march across the surface of the painting, barring the viewer from experiencing the full depth of the scene. The painting exceeds impressionist expectations and leans toward a postimpressionist abstraction of nature.

ACB

References:

Elizabeth Broun, "Childe Hassam's America," *American Art* 13, no. 3 (Autumn 1999): 33–57.

Kathleen M. Burnside, *Childe Hassam in Connecticut* (Old Lyme, CT: Florence Griswold Museum, 2002).

Julia B. Rosenbaum, *Visions of Belonging: New England Art and the Making of American Identity* (Ithaca, NY: Cornell University Press, 2006).

H. Barbara Weinberg, *Childe Hassam, American Impressionist* (New York and New Haven, CT: Metropolitan Museum of Art and Yale University Press, 2004).

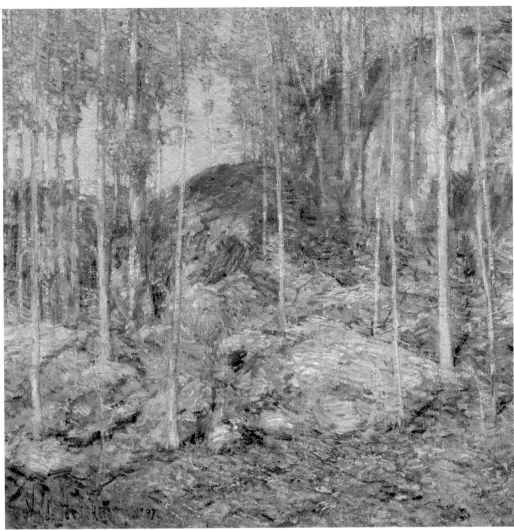

Plate 9

Everett L. Warner (1877–1963)

Plate 10
The Village Church, circa 1910
Oil on canvas, 32 x 26 inches
Florence Griswold Museum

In the early morning hours of July 3, 1907, Old Lyme's Congregational Church mysteriously burned to the ground. This beautiful meetinghouse, designed by Samuel Belcher and built in 1817, was the town's most prized building and an iconic image for the artists to paint. Childe Hassam's celebrated series of views of the church—done between 1903 and 1906—did much to popularize the colony and prompted other artists, such as Charles Ebert and Everett Warner, to try their hand at this subject.

With the help of the community and many of the Lyme artists, the church was rebuilt by 1910. Art historians William Truettner and Thomas Denenberg have observed in their essay "The Discreet Charm of the Colonial": "The haste to rebuild, one suspects, was to some extent driven by the need to restore the image of the town created by the Old Lyme painters." *The Village Church* portrays the newly built church from a discreet distance so that one is not aware of the newness of the clapboarding or the loss of the elms that once surrounded it. Like Hassam, Warner emphasizes the timelessness of the building's classical form over the details of its recent rebirth.

JWA

References:

Helen K. Fusscas, *A World Observed: The Art of Everett Longley Warner 1877–1963* (Old Lyme, CT: Florence Griswold Museum, 1992).

William H. Truettner and Thomas Andrew Denenberg, "The Discreet Charm of the Colonial," in *Picturing Old New England: Image and Memory*, eds. William H. Truettner and Roger B. Stein (New Haven, CT: Yale University Press, 1999), 77–109.

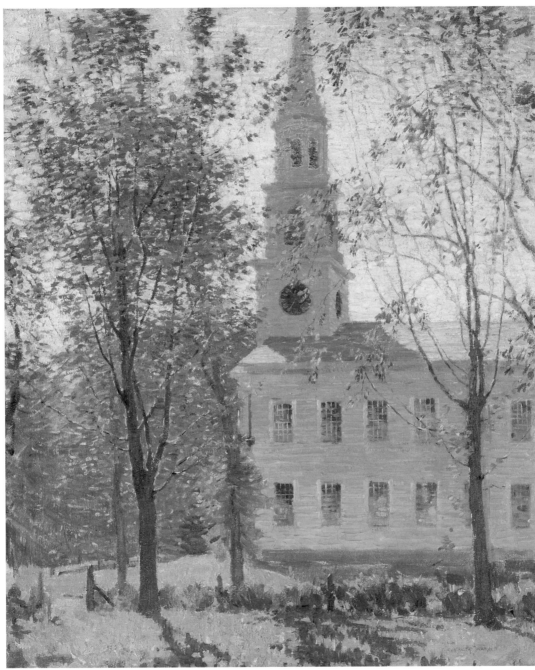

Plate 10

Charles Ebert (1873–1959)

Plate 11
House on Lyme Street, undated
Oil on canvas, 20 x 25 inches
Florence Griswold Museum

In 1919 Charles Ebert and his wife, the artist Mary Roberts Ebert, moved from Greenwich to Old Lyme, where they bought a large house and property on the main street of the village. The subject of this painting, the Deming-Avery House, was located next door. But the choice to portray this house was more than mere convenience. It was one of the earliest homes in town, having been built in 1726. An appreciation for the town's early architecture and history was part of the colony's stock-in-trade. Fellow colonist Frank Vincent DuMond acknowledged how "the village is one of the oldest in New England, and is one of the few remaining places which still possesses the characteristics expressive of the quiet dignity of other days" (DuMond, 7).

While the subject may be a bit old-fashioned, Ebert's palette—a bold impressionist mix of cool violets and goldenrod yellows—is decidedly not. *House on Lyme Street* is infused with the scintillating light of an autumn day.

JWA

References:

Frank Vincent DuMond, "The Lyme Summer School and Its Theory of Art," *Lamp* 27 (August 1903): 7.

Robert P. Gunn and Fenton L. B. Brown, *Charles H. Ebert (1873–1959)* (New London, CT: Lyman Allyn Museum, 1979).

Plate 11

Clark Greenwood Voorhees (1871–1933)

Plate 12
December Moonrise, circa 1906
Oil on canvas, 28 ¼ x 36 inches
Florence Griswold Museum

Clark Voorhees was among the earliest artists to visit Old Lyme, eventually suggesting the locale to his good friend Henry Ward Ranger. A consummate outdoorsman, Voorhees took frequent bicycling and sailing trips, which brought him to the region where he eventually settled on a permanent basis. Prior to making his home in Lyme, he studied at the Art Students League in New York and at the Académie Julian, in Paris. His excursions brought him into frequent contact with artist colonies at Barbizon in France, Laren in Holland, Peconic on Long Island in New York, and the newly formed colony at Cos Cob. In later years he revealed skepticism about colony life, writing, "At first they're made up of a few good men. Then the floaters and hangers-on come in and spoil everything. It's the social life that keeps those places going, and that saps your energy so that you can't work. Some of the artists may accomplish something, but they're the ones that would get ahead anywhere" (Beer, 11).

In 1903 Voorhees purchased a house on the Connecticut River at Old Lyme with the unusual feature of a freestanding studio built on pilings directly over the water. From this vantage point he could explore the surrounding Connecticut countryside and paint it over the course of all four seasons. Two of his preferred subjects, moonlit nights and winter scenes, combine in *December Moonrise.* In an extended discussion of the 1908 exhibition at the Old Lyme Public Library, an anonymous critic writing for the *New York Times* praised the painting as "so large, so simple, and quiet that at first glance it has a look of emptiness but its dignity and spaciousness grow upon one with every moment of attention given to it."

ACB

References:

Richard Beer, "As They Are," *Art News,* May 1934, 11.

"Exhibition of the Paintings by Lyme Artists," *The New York Times,* September 6, 1908, np.

Barbara Novak, *Next to Nature: American Landscape Painting from the National Academy of Design* (New York: National Academy of Design, 1980).

Barbara J. MacAdam, *Clark G. Voorhees, 1871–1933* (Old Lyme, CT: Lyme Historical Society, 1981).

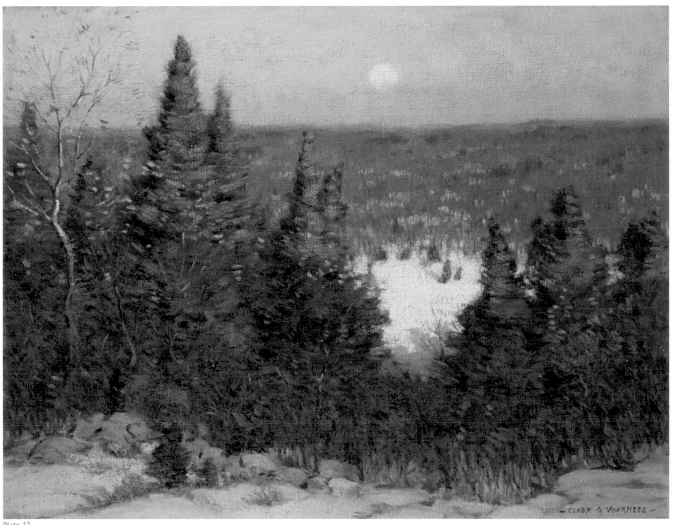

Plate 12

Everett L. Warner (1877–1963)

Plate 13

Winter on the Lieutenant River, undated
Oil on canvas, 20 x 25 ¾ inches
Florence Griswold Museum

Everett Warner became friends with a number of the Lyme artists—William Chadwick, Harry Hoffman, and Arthur Spear, among others—through their shared study at the Art Students League in New York during the first years of the twentieth century. In 1903 Warner went to Paris to study at the Académie Julian and, while there, shared a flat in the Latin Quarter with Hoffman and Spear. Eventually, and perhaps inevitably, Warner came to Old Lyme in 1909 and stayed at the Griswold House. This would be the first of many such visits to the colony's boardinghouse.

Warner delighted in the company of Florence Griswold and his fellow artists. He was asked to contribute a panel in the dining room, a testament to his acceptance by the group. He painted a winter scene of cedars and rocky outcroppings, something of a specialty for the artist. *Winter on the Lieutenant River,* painted from the edge of Miss Florence's property, captures the damp cold of coastal New England with chalky tones of violet and cobalt blue. The scene is remarkably similar today, even to the detail of the partially submerged rocks in the foreground.

JWA

Reference:

Helen K. Fusscas, *A World Observed: The Art of Everett Longley Warner 1877–1963* (Old Lyme, CT: Florence Griswold Museum, 1992).

Plate 13

Willard Leroy Metcalf (1858–1925)

Plate 14
Dogwood Blossoms, 1906
Oil on canvas, 29 x 26 inches
Florence Griswold Museum

Willard Leroy Metcalf often selected subjects seen through a screen of trees. In *Dogwood Blossoms,* the trees themselves, not the women, become the focus of attention. The women do not even appear aware of the artist's gaze in this sylvan springtime scene, recalling the candid moments captured by the French pleinairist Jules Bastien-Lepage. Although Metcalf had moved away from the intimately scaled compositions of Bastien-Lepage and other Barbizon-style painters by 1906, the dreamy mood remains.

Dogwood Blossoms dates from a very productive spring and summer spent in Old Lyme. Metcalf first visited the area in 1905, on the recommendation of his friend Childe Hassam. At that moment he was in the midst of what he called his "Renaissance," having rededicated himself to painting from nature. His "renaissance" work, consisting of landscapes from up and down the New England coast, was critically well received, and he was on the verge of financial success as well. Throughout the 1906 season spent at Florence Griswold's boardinghouse, Metcalf worked steadily, took students, and generally enjoyed the time spent outdoors collecting bird eggs and fishing.

ACB

References:

Richard J. Boyle, *Willard Leroy Metcalf: An American Impressionist* (New York: Spanierman Gallery, 1995).

Bruce W. Chambers, *May Night: Willard Metcalf at Old Lyme* (Old Lyme, CT: Florence Griswold Museum, 2005).

Elizabeth de Veer and Richard J. Boyle, *Sunlight and Shadow: The Life and Art of Willard L. Metcalf* (New York: Abbeville Press, 1988).

Lisa N. Peters, *Visions of Home: American Impressionist Images of Suburban Leisure and Country Comfort* (Carlisle, PA: Trout Gallery, Dickinson College, 1997).

Plate 14

Edward F. Rook (1870–1960)

Plate 15
Laurel, circa 1910
Oil on canvas, 40 ¼ x 50 ¼ inches
Florence Griswold Museum

Awarded a gold medal at the Panama-Pacific Exposition in San Francisco in 1915, *Laurel* was, and remains, Edward Rook's most celebrated painting in a career marked by artistic independence and indifference to the marketplace. According to artist Nelson C. White, "Rook was noted for his originality of approach to almost every subject, not only in his art but in his daily life" (Spencer et al., 171). Although his work was greatly esteemed by fellow artists of the Lyme Art Colony, Rook sold few works during his lifetime. Reclusive by nature, this Edwardian gentleman was adverse to promoting his own work, never had a dealer, and regularly attached high prices to his paintings so they would not sell.

Instead, he sent paintings to major exhibitions in America and abroad and received numerous awards and exhibition prizes. *Laurel,* for example, was shown in London, Cincinnati, Pittsburgh, and New York, as well as San Francisco. Reportedly it took Rook two years to complete this ambitious painting. His painstaking methods are evident on the surface of the painting, in which the flowering laurel blossoms, encrusted with impasto, seem as solid and unmoving as the boulder nearby. Legend has it that he tied dyed cotton balls onto his subject to "extend" the blooming season in order to finish the painting.

JWA

References:

Jeffrey Andersen and Hildegard Cummings, *The American Artist in Connecticut: The Legacy of the Hartford Steam Boiler Collection* (Old Lyme, CT: Florence Griswold Museum, 2002).

Diane Pietrucha Fischer, *Edward F. Rook: American Impressionist* (Old Lyme, CT: Florence Griswold Museum, 1987).

Harold Spencer, Susan G. Larkin, and Jeffrey Andersen, *Connecticut and American Impressionism* (Storrs, CT: William Benton Museum of Art, 1980).

Plate 15

Ernest Albert (1857–1946)

Plate 16
Autumn Day, Connecticut, undated
Oil on canvas, 30 x 32 inches
Florence Griswold Museum

After establishing his career as a scenic designer in the theaters of several major American cities, Ernest Albert decided to devote more time to his easel painting. In 1908 he and his artist son E. Maxwell Albert visited Old Lyme as boarders at Florence Griswold's house, where they could focus on landscape. In contrast to the great variety of scenes and sets required in his theatrical work, from Shakespeare to the Ziegfeld Follies, Albert's landscape painting demonstrated a steady consistency. Views of autumn and winter landscapes, such as *Autumn Day, Connecticut,* recur in his paintings. Albert's visits to Old Lyme and farther afield to Monhegan, beginning in 1915, became a regular part of his summers in the latter half of his life.

Albert's work may be unfamiliar to admirers of American impressionism. Immediately following his death, his family gathered together his known and available works, keeping them out of public view. His easel paintings began to emerge again only in the 1980s. Ironically, part of the reason Albert made the switch from the theater was the disappointment of seeing his large painted backdrops destroyed after the run of a show. An artist actively pursuing recognition, Albert was particularly outraged when, in the National Academy of Design's winter 1914 exhibition, his work fell into the "Accepted But Not Hung" category due to a lack of space, prompting him to found an independent exhibition group that would become the Allied Artists of America.

ACB

References:

Ernest Albert, exhibition catalogs (Boston: Vose Gallery, 1981 and 1987).

Impressionist Moods: An American Interpretation, exhibition catalog (New York: Grand Central Art Galleries, 1979).

Susan G. Larkin, *The Cos Cob Art Colony: Impressionists on the Connecticut Shore* (New York and New Haven, CT: National Academy of Design and Yale University Press, 2001).

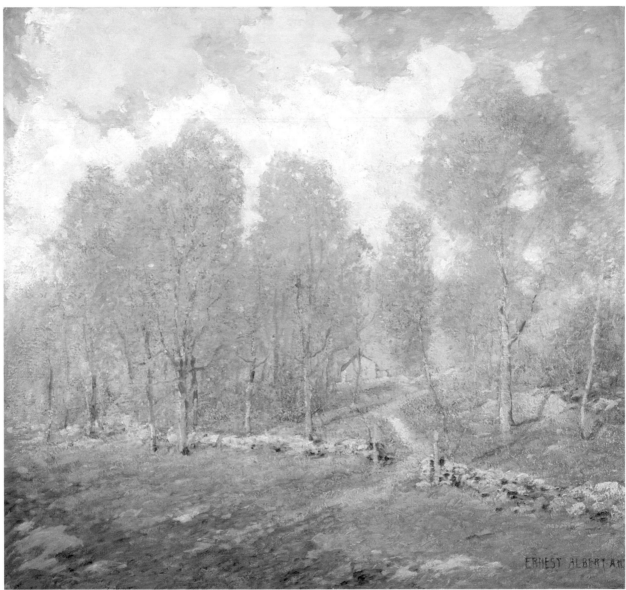

Plate 16

Emil Carlsen (1853–1932)

Plate 17

Godwin's Ridge, Greenwich, Connecticut,
1912
Oil on canvas, 24 x 36 inches
Florence Griswold Museum

Danish-born Emil Carlsen trained as an architect before immigrating to the United States in 1872. Over the next two decades, he studied and taught art in Chicago, Paris, San Francisco, and New York and built a reputation as a still-life painter. In 1896 Carlsen began summering in Connecticut, where he took up the subject of landscape. At first he stayed at the home of artist J. Alden Weir in Windham Center, even residing with his family in a cottage on Weir's property. In 1905 Carlsen bought a place of his own in Falls Village, in the northwestern corner of the state. According to his son, the artist found Falls Village by mistake. He set out to visit the art colony at Old Lyme, but through a misunderstanding with the ticket agent, he instead purchased a ticket to Lime Rock, Connecticut. In exploring the area, he came upon Falls Village, where he would summer for decades to follow.

Although not formally affiliated with an art colony, Carlsen maintained close relationships with several Connecticut painters, including Willard Metcalf, Childe Hassam, and Weir, and is most closely associated with the circle at Cos Cob. The limited tonal range and carefully constructed surface of *Godwin's Ridge* recall the work of John Henry Twachtman, whose paintings Carlsen admired. Carlsen's intimate response to nature creates a hushed, dreamlike mood that is the hallmark of his landscapes.

AKL

References:

Jeffrey Andersen and Hildegard Cummings, *The American Artist in Connecticut: The Legacy of the Hartford Steam Boiler Collection* (Old Lyme, CT: Florence Griswold Museum, 2002).

The Art of Emil Carlsen, 1853–1932, exhibition catalog (San Francisco: Rubicon-Wortsman Rowe Publications, 1975).

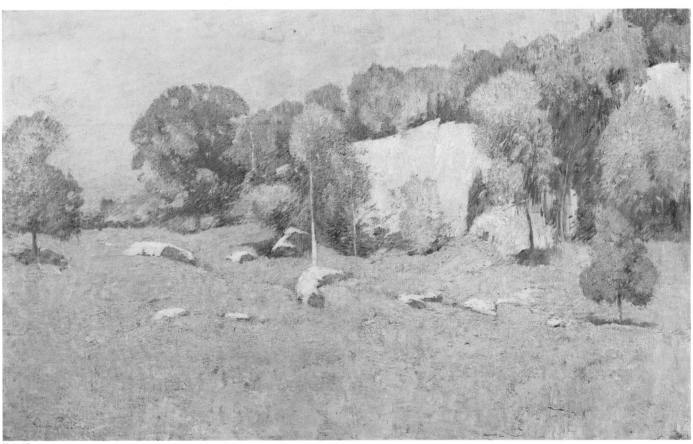

Plate 17

Ogunquit: The Old Fashioned and the Modern

We shall be true to the traditions of our great apostles of democracy—Lincoln, Walt Whitman, and Winslow Homer.
—Hamilton Easter Field, 1913[1]

OGUNQUIT, A SLEEPY SMALL TOWN on the rocky coast of Southern Maine, served as the unlikely fault line between two artistic cultures in the opening decades of the twentieth century (plate 18). By the time of World War I, however, the picturesque fishing village had become nothing less than contested terrain in an ideological conflict between artists who traded in the regionalist image of "old" New England and those hewing to a modernist worldview. Both camps—traditionalist and the avant-garde, Bostonians and New Yorkers, acolytes of Charles Herbert Woodbury and those of Hamilton Easter Field—found a ready home in Ogunquit, as the unique geographical and historical features of the place held sway over a broad spectrum of visitors.

Ogunquit, much like Old Lyme, initially attracted a uniform group of like-minded artists—Boston painter Charles Woodbury and his students. Woodbury, a well-known teacher who built a summer home and studio on Perkins Cove (plate 19), established a course of instruction that literally put Ogunquit on the map as an art colony in the waning years of the nineteenth century. Initially attracted to the narrow cove and surrounding coastal geology, Woodbury and his followers were no doubt also appreciative of the genteel reputation of their summer venue. "The social atmosphere of Ogunquit is uniformly high-class," noted a popular travel guide in 1911, as "there is no near-by town to pour forth its noisome rabble."[2] Woodbury's students could frequently be found throughout the town, perched on rocks sketching the breakers and setting easels down in pastures. Local residents were bemused, even astonished at times, by the artists in their midst, and stories of their interaction soon became the stuff of legend. One farmer is reported to have said of Woodbury, "I don't know how he could have got 150 dollars for a picture of my cow. I didn't give but 35 for her in the first place, and it don't look like her anyway."[3]

Woodbury "discovered" Ogunquit in 1888 while on a trip to visit his fiancée, Marcia Oakes, at her family summer home in neighboring York Beach. The painter spent his first days in the fishing village renting a room at the Ogunquit House, a tourist accommodation on Shore Road. Woodbury's generation gravitated to the coastal region between Portsmouth, New Hampshire, and Kennebunk, Maine, in the last decades of the nineteenth century and transformed the region from an economic backwater after the Civil War to a landscape of tourism experience that presaged mid-twentieth-century Maine as "Vacationland" (plate 20).[4] Stratified by economic class, the towns that surrounded Ogunquit provided a summer haven for the wealthy and literary elites such as William Dean

Howells, Samuel Clemens, and Sarah Orne Jewett, boardinghouses for middle managers and their families, and affordable hotels for working-class "excursionists."[5]

Ogunquit and nearby communities benefited from a geology guaranteed to attract painters and tourists conditioned to appreciate scenery. Vacation brochures proudly translated the Native American place name Ogunquit as "beautiful place by the sea" and listed a seemingly endless string of enticing natural features including Gull Rock, Spouting Rock, Natural Bridge, Watch Dog, Pirates' Cove, and Lobster Point, as well as Marginal Way and Perkins Cove.[6] Ogunquit's attractions boasted not only physical beauty in an era that promoted exposure to the great outdoors as an antidote to the hustle and bustle of urban life but cultural relevance as well, for the towns along the Piscataqua River and the coast of southern Maine enjoyed a useful past in the form of a storied colonial history. Nearby York—soon to be known as "Old York"—boasted two seventeenth-century garrison houses mythologized in the period as fortified dwellings for life on the rugged frontier.[7] These hoary structures, along with York's "Old Gaol," had long been the subject of antiquarian interest and provided the surrounding area with an enchanting narrative of heroic pioneer life as a backstory for modern visitors. "Vacation promoters," notes historian Dona Brown, "by the 1880s had already become adept at distinguishing the towns of the Piscataqua from their competitors at Mount Desert or the White Mountains by their rich history."[8]

Old houses and myths of colonial life engendered a sense of timelessness in the landscape around Ogunquit and proved important to attracting tourists. Coastal steamship lines and, most especially, the Boston and Maine Railroad were well-established modes of passenger transportation by the last quarter of the nineteenth century. Electric trolley cars crisscrossed the region, taking tourists to Kennebunk, Cape Porpoise, and Old Orchard Beach. But Ogunquit, at least initially, was bypassed by railroad and streetcar.[9] A travel guide of 1917 noted that in the 1890s Ogunquit "was a small, isolated fishing village

reached only by stage."[10] Some years later the sculptor Robert Laurent recalled the trip to Ogunquit as a journey just short of a pilgrim's progress: "We had left Brooklyn a few days before, on a boat of the old Fall River Line and had landed by train at York Beach, then the end of the line. We hired a horse and buggy and drove along the shore road. When we reached Ogunquit we felt that we had found the perfect spot. . . . We settled at Perkins Cove."[11] Traveling to Ogunquit seemed akin to venturing back in time, an attractive proposition for many at the turn of the century.

The Charles Woodbury who ventured to Ogunquit serves an archetype of his era. Born in Lynn, Massachusetts, in 1864 to a family of engineers and inventors, Woodbury enjoyed impeccable New England ancestry, yet his father pursued the most modern of professions in a city known internationally for high-volume textile production.[12] Like his contemporary Childe Hassam, a Bostonian of old family born to a generation of hardware merchants, Woodbury rejected a prescribed career to follow his artistic leanings. Woodbury garnered attention at a young age, in 1882, when he exhibited at the Boston Art Club, the very year that the venerable institution's elegant Back Bay clubhouse opened. Bowing to familial pressure and the growing movement toward professional life, he enrolled at the Massachusetts Institute of Technology that same year and graduated in 1886, with honors in mechanical engineering.[13] While at MIT, Woodbury maintained his interest in the arts by enrolling in evening classes at the Boston Art Club. Eschewing a career in business, he supported himself by teaching and painting, and the chance enrollment of Marcia Oakes in an early class led him to Maine.

Woodbury's move to Maine proved to be transformative for the painter, the town, and for American visual culture. After marrying Oakes, traveling extensively in Europe, and establishing his career after a period dedicated to teaching in and around Boston, Woodbury and his wife purchased land on Perkins Cove in 1896 and built a studio the following year (fig. 14). In 1898 they constructed a large, shingle-style cottage, with a dramatic saltbox profile and a jetty, or overhang, reminiscent of

Fig. 14. Unidentified photographer, Mr. Woodbury's studio, exterior, 1937, gelatin silver print. Collections of Maine Historical Society.

Fig. 14

nearby historic houses. Woodbury began instruction in his summer school that same year, a six-week course that endured until American intervention in World War I appeared imminent in 1917 and then was later reborn after the Armistice.

Woodbury's school attracted between sixty and a hundred students per summer, who paid forty dollars for the course of instruction.[14] The students—men and women, neophytes and professionals—descended upon the small village, filling boardinghouses and hotels. Fanning out across the landscape, the aspiring artists set up easels under umbrellas on the rocky coast, in pastures, and on nearby hills. Woodbury emphasized personal instruction, formally demonstrating composition and then moving from one student to the next, offering advice and criticism (fig. 15). Newspaper reports and student recollections record Woodbury's keen interest in technique, a legacy of his training as an engineer. His more poetic instincts, however, found their way into print.[15] "One must," he wrote, "get at the inside of the hill, the ledge, the tree, delve into its elemental nature." Favoring an elliptical mode of representation, he advised followers to "imply more than you ever paint, or the interest will flag." Mystery was one thing, abstraction another. "You can't," he cautioned, "expect the public to understand your own arbitrary symbols."[16]

Woodbury preached direct observation above all. "I might say," he wrote, "all my knowledge has been gained in the open air."[17] Dedication to painting en plein air aligned Woodbury's summer classes in Ogunquit not only with mainstream artistic practice dating to mid-nineteenth-century France, when Paris-based artists made their initial forays to the small town of Barbizon, but also to the movement toward the outdoor life in the decades that bracketed the turn of the century in the United States. Although Woodbury attracted a broad spectrum of students and mentored both men and women, his summer school took on a decidedly female cast before long. Not only were painting classes long established as an appropriate activity for women of genteel station, but the culture at Ogunquit combined the therapeutic pastimes of creative expression, social intercourse, and fresh air in an amalgam uniquely suited to combating rising concerns about neurasthenia, a nervous disorder, among women and increasingly feminized professional men.

"Neurasthenia," writes historian Harvey Green, "had first been defined by George Beard in the 1870s as a sign of advanced civilization."[18] A case of the nerves might well be taken as a badge of refinement. By the turn of the century, however, the disease was viewed as the principle complaint of the Victorian middle class and often identified as an impediment to professional advancement for men and domestic happiness for women. Activities that promoted social interaction and handiwork, such as bookbinding, woodworking, and metalworking, gained great currency as the theories of the arts-and-crafts movement were adopted as mainstream pastimes. Better still were avocations that required advanced levels of technical and artistic commitment, as the wisdom of the day prescribed photography, printmaking, and painting as antidotes for incipient neurasthenia. Photography clubs and painting associations cropped up in cities and towns to encourage aesthetic advancement and camaraderie.[19]

Travel offered yet another cure for the nerves. Rural settings proved particularly therapeutic, and Ogunquit vied with camping in the Adirondack wilderness of upstate New York or far western travel for those who could afford the diversion. Authenticity of experience and interaction with local populations were viewed as especially restorative, although encounters between summer folk and locals invariably produced amusing anecdotes. Tales of Woodbury's expensive cow made the rounds, as did that of a perplexed farmer interviewed by the *Lewiston Journal* in 1906. "He scootched up on the beach," reported the farmer about an artist, "and drafted something with a smut of coal, painted it all red, blue and yellow, and called that a picture."[20] Humor aside, "the rural population along the Maine coast," observed photographer and travel writer Clifton Johnson approvingly in 1902, "is composed almost wholly of Yankees of the purest strain." Not only could visitors and summer folk find "real" Americans in the

Fig. 15

Fig. 15. Unidentified photographer, Charles Woodbury painting with his class, undated, gelatin silver print. Maine Historic Preservation Commission.

Fig. 16. Charles Herbert Woodbury, *The Rising Tide*, undated, etching on wove paper. Portland Museum of Art.

Fig. 17. Gertrude Fiske, *Low Tide*, undated, etching on heavy wove paper. Portland Museum of Art.

Fig. 18. Hamilton Easter Field, *Self-Portrait*, circa 1898, oil on panel. Portland Museum of Art, Maine. Hamilton Easter Field Foundation Collection. Gift of the Barn Gallery Associates, Inc., Ogunquit, Maine.

coastal towns, a people seemingly at one with their community and environment, but the pace of life appeared attractive as well. Commenting on the "serene lack of haste" that he observed, Johnson noted that "'forced-to-go never gits far' was a sentiment that seemed to have found universal acceptance in the rustic fishing village."[21]

Along with local characters, historical associations, and physical setting, Woodbury's students themselves became a tourist attraction before too long. Louise Hale, author of the travelogue *We Discover New England*, wrote of arriving in the village by touring car. "Studios with great north skylights were part of many cottages," she remarked, along with mention of "maidens [who] sat in meadows, braving cows to paint the cliffs."[22] Hale's anecdote, again echoing popular tales of urbanites in the country, is pointedly gender specific. By the time she observed "maidens in meadows" in 1916, Woodbury's summer school had already acquired a reputation as a haven for single women from proper Boston families. Locals, punning on the name of the well-known path by the coast, called them the "Virginal Wayfarers."[23]

The women of Woodbury's circle, including Charlotte Butler, Amy Cabot, Susan Ricker Knox, Grace Morrill, Elizabeth Sawtelle, and Gertrude Fiske (plate 21), represented a trend in upper-class New England society. Too wealthy, conservative, or old to be "new women" or flappers, Woodbury's female students enjoyed the resources of their families yet often bypassed traditional domestic expectations to forge bonds among themselves and create a tight-knit summer community. Some purchased land in Ogunquit from Woodbury to build studios themselves, and others rented cottages until the group dissipated, around the time of World War II.

Gertrude Fiske, a direct descendant of colonial governor William Bradford of Massachusetts Bay Colony, transcended the amateur taint of the Virginal Wayfarers. A student of Edmund Tarbell, Frank Benson, and Philip Hale at Boston's School of the Museum of Fine Arts, Fiske completed that institution's rigorous seven-year curriculum in 1912. Her early work closely resembled the Boston tradition of portraiture in that it owed a debt to the studied use of light, shadow, and attention to detail employed by the Dutch old masters. Fiske's time at Woodbury's school in Ogunquit, however, led her to a rigorous style that set her apart from her peers (plate 22). Internalizing Woodbury's theories of color and robust use of the brush, Fiske achieved critical acclaim. Indeed, the *Boston Sunday Herald* proclaimed her "a probable celebrity" for her "brilliant emotionality."[24] Fiske also championed professional associations for artists in Ogunquit and back at home. She was a founding member of the Ogunquit Art Association as well as the Concord Art Association and the Guild of Boston Artists.[25]

Woodbury's influence on Fiske can readily be seen in her printmaking (figs. 16 and 17). Frequently taking Ogunquit scenes as her subject, Fiske's rocks, water, and bathers also recall Frank Benson's work. Fiske maintained an etching press in her Weston, Massachusetts, studio and printed her own editions, inking the plates by hand and signing the works for exhibition.[26] Professional associations again proved important to Fiske in her graphic work, and she was a member of both the Chicago Society of Etchers and the Boston Society of Etching. Fiske's works on paper, reminiscent of Whistler and other luminaries who revived etching in the late nineteenth century, recall her interest in the craft of her art and tie her closely to Boston academic traditions.

The rustications of well-to-do Bostonians such as Woodbury and Fiske were interrupted by the arrival of Hamilton Easter Field, a charismatic New York modernist (fig. 18). Field, having scouted Ogunquit with his protégé Robert Laurent after the turn of the century, established his own school in 1911, calling the venture the Summer School of Graphic Arts and describing the endeavor as "an art school devoted to individual expression."[27] As the scion of an old Quaker family, Field enjoyed comfortable circumstances that allowed him the freedom to dabble at college, travel and live in Europe, paint, and serve as an important catalyst for modern art in the United States. In the course of his brief life, he founded schools in Ogunquit and Brooklyn and opened the Ardsley Studios, a gallery run

Fig. 16

Fig. 17

Fig. 18

out of his home which provided an important venue for modernists including John Marin, Marsden Hartley, Abraham Walkowitz, and Marguerite and William Zorach. He wrote reviews for the *Brooklyn Daily Eagle,* founded the influential journal the *Arts,* and was a member of the Society of Independent Artists, a group dedicated to organizing a nonjuried annual exhibition of nonrepresentational art. Field was the only collector, other than Alfred Stieglitz, to purchase a work from Picasso's 1911 exhibition at Gallery 291, in New York.[28] His most important role, however, was as paterfamilias to an emerging group of avant-garde painters and sculptors. He exhorted his students to "open your eyes wide, get the local tang. There's as much of it right here in Maine as there is in Monet's Normandy. But to get it you must live in touch with the native Ogunquit life, just as Monet wears the sabots and peasant dress of Giverny."[29]

Field sought to intensify this local "tang" by purchasing and renovating an old house on Perkins Cove. He organized the construction of a series of studios nearby reusing fragments of old barns and a number of fishermen's shacks to create a compound for his followers.[30] In doing so, wrote the painter Elsa Rogo, Field "delighted to show his contempt for the architect's blueprint slavery by directing the layout himself, on the spot, trusting his eye rather than the ruler."[31] Field and Laurent decorated the structures with locally gathered examples of indigenous objects from the eighteenth and nineteenth centuries—weather vanes, decoys, and portraits. Field reconstructed Ogunquit to fit his sensibilities, thereby creating a fantasy of life along the New England coast for his New York–based ensemble of international modernists.

Once again, the built environment proved important to the story of Ogunquit. Unlike the tourists and artists who were initially attracted to southern Maine by the storied colonial buildings, Field focused upon prosaic, like-sized fishing shacks found tightly clustered along Perkins Cove (fig. 19). The small buildings were a legacy of the Cove Fish Company, a cooperative initially founded in 1856, when fifteen members banded together to purchase land and divide the holdings into

Fig. 19

Fig. 20

twenty-foot plots on the cove so they could land and repair fishing boats.[32] The lightly framed shacks grew by accretion over the years to form a unique geometry that proved irresistible to artists seeking authenticity of experience while experimenting with cubism and abstract form. Gaston Longchamps's 1933 painting of Bish Young and Charlie Adams (plate 23), two Ogunquit fishermen, is typical not only of the physical setting of Field's school but also of the relationship between locals and artists "from away."

The differences between Field's modernists and Woodbury's more traditional set were manifest. One student recalled that the "Field School seemed to have a younger, fun-loving group who (took) to dancing a Valentino tango or playing the latest records. Whereas, the Woodbury-ites seemed older, quieter, and more sedate."[33] Another wrote of the day "a young European countess who modeled for at least one summer at Field's school jumped up from a nude pose, grabbed an Oriental kimono, and dashing across the little rickety bridge [fig. 20] to the other side of the cove, flung herself nude on the steps of Woodbury's studio and proceeded to sunbathe."[34] Field's followers (figs. 21 and 22), nudity aside, were a worldly, heterogeneous lot who had little in common with the proper Boston women of Woodbury's school.

Field's side of Perkins Cove quickly became the province of New York artistic circles. The school served as a de facto northern venue for the young students of Kenneth Hays Miller, then professor at the Art Students League in New York City. As art historian Doreen Bolger has noted, the enrollment in Field's summer school was modest when compared to Woodbury's but included individuals destined to shape American visual culture, including Yasuo Kuniyoshi, Niles Spencer, Stefan Hirsch, and Lloyd Goodrich—the future museum director and scholar who would help create the canon of American art in the 1940s and 1950s. One of Field's first converts to life in Ogunquit was Bernard Karfiol.

"I never tire of painting Maine," wrote Karfiol, "it has a character quite different from inland country. . . . One never feels closed in." He continued, the "ocean with its

rocky coast has a great fascination . . . the beautiful scrub pines so characteristic of the back country, provide fine backgrounds for my figure subjects"[35] (plates 24 and 25). Yet Karfiol was hardly a regionalist. Although he was proud to note that his father worked for J. H. Bufford, the same Boston lithography firm that nurtured a young Winslow Homer, Karfiol was a very different painter than the hermit of Prouts Neck. "Karfiol's work," wrote a biographer in 1931, "will always be exceptional in a community which owns to a Puritan tradition in its immediate past." New England—especially an Ogunquit teeming with Woodbury's virgins—simply did not confront the body. Karfiol's "mellow paganism" and "attitude toward the nude figure was never native to Anglo-Saxon soil."[36]

Karfiol first met Hamilton Easter Field in 1912 and accepted the latter's invitation to paint in Ogunquit the following summer. Karfiol recalled, "For living quarters he offered me a large one-room shack which served as a fish-house before the Civil War."[37] The Budapest-born Karfiol and Field were kindred spirits. Karfiol, raised as a prodigy in Boston and Brooklyn to progressive parents, eventually attended classes at Pratt Institute and the National Academy of Design—but only after his mother had to be informed that Cooper Union was not a kindergarten! Recalling his journeyman years, Karfiol observed, "art seemed dormant" in the United States in the opening decade of the twentieth century. "A few Impressionists slipped into American consciousness, but generally it was desert land." The Metropolitan Museum, he remembered, was small and old, "comprised [of] only the red brick section" of the present grand edifice, and "J. G. Brown and Charles Dana Gibson were considered most important" artists. His answer was to escape to Paris in 1901, where he studied at the Académie Julian and met Bougereau, Picasso, Matisse, Rousseau, and "saw a good deal of Leo and Gertrude Stein."[38] A dyed-in-the-wool modernist, Karfiol proved especially attractive to Field's crowd.

Karfiol's interest in Maine—aided and abetted by Field—is typical of a generation of modernist pilgrims who discovered in the material culture of earlier generations a direct expression that cut against the grain of sentimental Victorian representation. Karfiol—who came of age in an era that prized J. G. Brown's quaint paintings of bootblacks but exhibited in the modernist coming-out party of the Armory Show in 1913—found transcendence in the decoys, weather vanes, and portraits that Field placed in the fishing shacks at Ogunquit. "In 1916," he recalled, "Robert Laurent and I took a walking trip further into the hills. We saw quantities of antique furniture in old farmhouses. Spending about $23.00 between us, we bought so many chairs, tables, and other choice objects that we were obliged to hire a haywagon to cart the stuff back to Ogunquit."[39] Such collecting, encouraged by Field as an analogue to contemporary European fascination with the arts of Africa and Asia, flowered into a wholesale appreciation of American folk art among elite circles. Edith Gregor Halpert, the pioneer dealer, studied in Ogunquit and credited Field as "responsible for directing attention to American folk art," declaring him the "pioneer in the field" in 1926.[40]

Yasuo Kuniyoshi proved to be uniquely sensitive to the environment that Field and Laurent constructed in Ogunquit. Born in Japan, Kuniyoshi immigrated to the United States in 1906 and made his way to New York, where he enrolled in Kenneth Hays Miller's class at the Art Students League. In 1917 Kuniyoshi participated in the Society of Independent Artists' annual exhibition and, thereby, met Hamilton Easter Field.[41] Field provided Kuniyoshi with studio space in Brooklyn and, more importantly, brought him to Ogunquit, where the indigenous culture struck a resonant chord.

Ogunquit played a key role in Kuniyoshi's development as a modernist. His earliest works in Maine are moody landscapes not unlike Ryder's; however, by the early 1920s, Kuniyoshi had internalized "the tang" of the place. Influenced by the old portraits, decoys, and weather vanes in Field's cottages, the young artist began experimenting with a flat picture plane and foreshortening of figures (plate 26) not unlike the work of nineteenth-century itinerant painters. Fascinated by the very shapes around him, including houses, barnyards,

Fig. 19. G. Herbert Whitney, general view of colony (Ogunquit), 1937, gelatin silver print photograph. Collections of Maine Historical Society.

Fig. 20. Leo Meissner, *Footbridge: Perkins Cove*, undated, wood engraving on wove paper. Portland Museum of Art.

Fig. 21. Bernard Karfiol, *Nude on Sofa*, circa 1930, oil on canvas. Portland Museum of Art, Maine. Hamilton Easter Field Foundation Collection. Gift of the Barn Gallery Associates, Inc., Ogunquit, Maine.

Fig. 22. Robert Laurent, *Reclining Figure*, circa 1935, walnut. Portland Museum of Art.

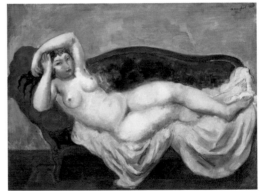

Fig. 21

Fig. 22

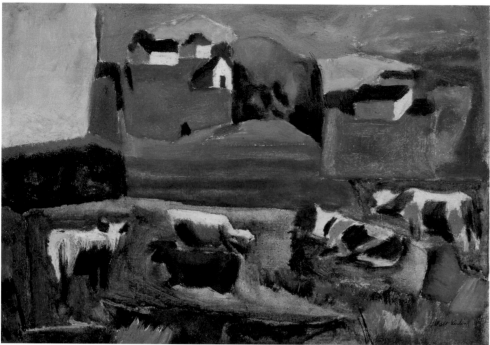

Fig. 23

Edward Hopper, captured the quality of light familiar to denizens of New England as a sign that summer is soon to end (plate 29).

Despite Field's early death, in 1922, Ogunquit remained a bastion of modernist thought as his school was carried on by Robert Laurent. Field's personal legacy was fixed in 1929, with the organization of the Hamilton Easter Field Art Foundation by five former students who raised funds to support a living tradition in his name (fig. 24). The creative tension between artists interested in a vision of old New England and those proclaiming the modern also remained in place until mid-century, when local institutions such as the Barn Gallery reached fruition and new endeavors like the Ogunquit Museum of American art were formed to preserve and interpret the town's remarkable role in the history of American Art. Not only does the story of Ogunquit inform the history of art colonies in the United States, but it also graphically illustrates that modernism and antimodernism were but two sides of the same coin in New England.[43]

Thomas Denenberg

even cows, Kuniyoshi synthesized local motifs within a modern language to create a mode that has been best described as "Yankee Modernism," by art historian Bruce Robertson.[42]

The idea of a "Yankee Modernism" contains paradoxes of both time and place: "Yankee," referring to the idealized, sometimes stereotypical, thrifty New England values from "days of old," and "modern" representing all that is new from cosmopolitan locales. Located between the poles of the "Yankee" and the "modern," however, comfortably sits the work of Field's Ogunquit artists. Of the many painters who passed through the community in the years between the world wars, few escaped without internalizing a sense of place compounded by a new way of seeing. Walt Kuhn, whose early work in town could perhaps be mistaken for Woodbury's, came to see the Maine landscape as a pattern of modern shapes and timeless motifs (fig. 23), much as Kuniyoshi did. Russian-born Abraham Walkowitz, later known for his depictions of dancer Isadora Duncan, brightened the view of Ogunquit with a modern palette and pared-down sense of the figure in the landscape (plate 27). Clarence Chatterton interpreted not only the social side of the sporting culture of high summer (plate 28) but, like his friend

Fig. 23. Walt Kuhn, *Landscape with Cows,* **1922, oil on canvas. Portland Museum of Art.**

Fig. 24. Unidentified artist, *Dinner, Dance, Auction: Field Foundation,* **undated, oil on canvas. Portland Museum of Art, Maine. Gift of the Laurent Family.**

[1] Hamilton Easter Field, *Technique of Oil Painting and Other Essays* (Brooklyn, NY: Ardsley House, 1913), 9.

[2] L. S. Woodruff, *Souvenir of Ogunquit Maine* (Boston, 1911). I would like to thank Earle Shettleworth for sharing this, and many other references, with me.

[3] Unidentified farmer as quoted in *Lewiston Journal,* August 7, 1937, in *Earth, Sea and Sky: Charles H. Woodbury, Artist and Teacher, 1864–1940,* eds. Joan Loria and Warren A. Seamans (Cambridge, MA: MIT Museum, 1988), 34.

[4] Construction of a bridge across the Ogunquit River in 1880 sparked a building boom of hotels, and the Riverside, Sparhawk, Highrock, and Sachem hotels all date to the last two decades of the nineteenth century.

[5] For more on the tourist trade in southern Maine, see Dona Brown, *Inventing New England: Regional Tourism in the Nineteenth Century* (Washington, DC: Smithsonian Institution Press, 1995), especially chapter 6, "The Problem of Summer."

[6] Pamphlet, *Ogunquit Maine* (circa 1939–40). Collections of Maine Historical Society. I would like to thank Nicholas Noyes, Jamie Rice, and Dani Fazio of the MHS library for their kind assistance.

7 These buildings captured the attention of artists of all stripes, including Winslow Homer, who in 1875 painted *The Old Garrison*, now in the collection of the Cooper-Hewitt.

8 Brown, *Inventing New England*, 181.

9 Streetcars made Ogunquit accessible in 1907 with the arrival of the Kennebunk, York Beach Line. See O. R. Cummings, *York County Trolleys* (Charleston, SC: Arcadia Publishing, 1999), 55.

10 Sargent's Handbook Series, *A Handbook of New England* (Boston: Porter E. Sargent, 1917), 706.

11 Laurent as quoted in *Hamilton Easter Field and the Rise of Modern Art in America*, Doreen A. Bolger (M.A. Thesis, University of Delaware, 1973), 4.

12 Louise Tragard, Patricia E. Hart, W. L. Copithorne, *A Century of Color, 1886–1986: Ogunquit, Maine's Art Colony* (Ogunquit, ME: Barn Gallery Associates, 1987), 7.

13 Ibid.

14 Loria and Seamans, *Earth, Wind and Sky*, 34.

15 Woodbury summed up twenty years of teaching in Charles H. Woodbury, *Painting and the Personal Equation* (Boston: Houghton Mifflin, 1919); and Charles H. Woodbury and Elizabeth W. Perkins, *The Art of Seeing* (New York: Charles Scribner's Sons, 1925).

16 Woodbury as quoted in Loria and Seamans, *Earth, Sea and Sky*, 33–34.

17 Ibid., 31.

18 Harvey Green, *Fit for America: Health, Fitness, Sport and American Society* (Baltimore: Johns Hopkins University Press, 1986), 259.

19 A typical example is the turn-of-the-century plein-air painting society know as the Brush-uns, of Portland, Maine. For a period exploration of the group, see L. L. H., "The Brushians: A Sketch of Genial Sketchers," *Pine Tree Magazine*, April 1906, 213–23.

20 Unknown farmer as quoted in Loria and Seamans, *Earth, Sea and Sky*, 33.

21 Clifton Johnson, *New England and Its Neighbors* (New York: Macmillan, 1902), 196–97.

22 Louise C. Hale, *We Discover New England* (New York: Dodd, Mead, 1916), 229.

23 Lindsay Pollock, *The Girl with the Gallery: Edith Gregor Halpert and the Making of the Modern Art Market* (New York: PublicAffairs, 2006), 52.

24 *The Boston Herald* as quoted in *Gertrude Fiske*, exhibition catalog (Boston: Vose Galleries, 1987), 5.

25 Tragard et al., *Century of Color*, 17.

26 *Gertrude Fiske*, 9.

27 Hamilton Easter Field, *The Technique of Oil Painting and Other Essays* (New York: Ardsley House, 1913), 84.

28 Sarah Greenough and Juan Hamilton, *Alfred Stieglitz: Photographs and Writings* (Washington, DC: National Gallery of Art, 1983), 229.

29 Field, *Technique of Oil Painting*, 58.

30 Doreen Bolger, "Hamilton Easter Field and His Contribution to American Modernism," *American Art Journal* 20, no. 2 (1988): 90.

31 Rogo as quoted in ibid., 91. Rogo was married to painter Stefan Hirsch.

32 Charles Seaman and Dorothy A. Seaman, *A Pictorial History of Ogunquit, Maine* (Ogunquit, ME: privately printed, 1993), Collections of the Maine Historical Society.

33 Unidentified student as quoted in Tragard et al., *Century of Color*, 37.

34 Ibid.

35 Bernard Karfiol, *Bernard Karfiol* (New York: American Artists Group, 1945), np.

36 Jean Paul Slusser, *Bernard Karfiol*, American Artists Series (New York: Whitney Museum of American Art, 1931), 7.

37 Karfiol, *Bernard Karfiol*, np.

38 Ibid.

39 Ibid.

40 Halpert as quoted in *Uncommon Treasures: Folk Art in Maine*, ed. Kevin D. Murphy (Camden, ME: Down East Books, 2008), 21.

41 Jane Myers and Tom Wolf, *The Shores of a Dream: Yasuo Kuniyoshi's Early Work in America* (Fort Worth, TX: Amon Carter Museum, 1996), 25.

42 For more on this, see Bruce Robertson, "Yankee Modernism," in *Picturing Old New England: Image and Memory*, William H. Truettner and Roger B. Stein (New Haven, CT: Yale University Press, 1999).

43 For more on antimodernism, see T. J. Jackson Lears, *No Place of Grace: Antimodernism and the Transformation of American Culture, 1880–1920* (New York: Pantheon, 1981).

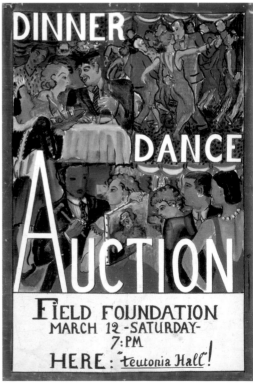

Fig. 24

Entries

Ogunquit

Walt Kuhn (1877–1949)

Plate 18

Lobster Cove, Ogunquit, 1912
Oil on canvas, 20 ⅛ x 24 ⅛ inches
Portland Museum of Art

This painting represents a key moment of transition in Walt Kuhn's art as well as American art in general. The years 1911 to 1913 brought change to Kuhn's life and career in many ways: in 1911 he celebrated the birth of his daughter, first visited Ogunquit, met Hamilton Easter Field, and began to work on organizing the Armory Show, a New York exhibition of international art in 1913 that would change the course of art in this country forever. The organizers of this exhibition railed against the conservatism and exclusivity of the annual exhibition hosted by the National Academy of Design; they also were dissatisfied with the direction of the anti-academy movement that had preceded them—led by Robert Henri—which favored a social-realist approach to painting.

By contrast, Kuhn enjoyed the relative artistic freedom of Ogunquit, facilitated by its distance from New York and also by its decidedly avant-garde community of artists. Shortly after he first arrived there, in 1911, he happily reported in a letter to his wife that Field had admired his work. Although never a full-fledged member of either the Field or Charles Woodbury circles, Kuhn associated freely with them as fellow artists and neighbors while he put down deep Ogunquit roots, purchasing a home there in 1920. Although nothing is particularly revolutionary about the subject of this painting of Ogunquit's rocky shoreline, the broken brushwork and spectral palette—note the marks of bright red in the foreground rocks—convey his willingness to experiment with modernist techniques.

JSR

Reference:

Philip Rhys Adams, *Walt Kuhn, Painter: His Life and Work* (Columbus: Ohio State University Press, 1978).

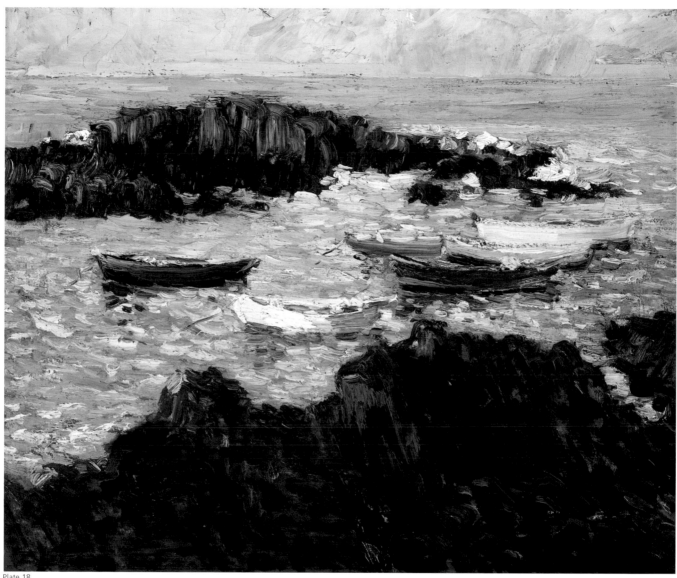

Plate 18

Charles Herbert Woodbury (1864–1940)

Plate 19

Perkins Cove, Maine, circa 1900
Oil on board, 10 x 13 ⅞ inches
Portland Museum of Art

Plate 20

Ogunquit Bath House with Lady and Dog,
circa 1912
Oil on board, 11 ⅞ x 17 inches
Portland Museum of Art

In 1898 Charles Woodbury opened the doors of the Ogunquit Summer School of Drawing and Painting. Woodbury himself was largely self-taught as a painter; although he took some watercolor classes under impressionist Ross Sterling Turner, his formal academic training was in mechanical engineering, in which he earned a degree from MIT, in 1886. Nevertheless, his talent was undeniable, and after selling out his first gallery show, he established a successful Boston studio and classroom. His future wife, Marcia Oakes of South Berwick, Maine, was one of his students there, and it was through her that he first came to visit Ogunquit, which was then little more than a cluster of fishing shacks along Perkins Cove. Woodbury saw in the unspoiled seaside setting and the quiet village atmosphere the perfect environment for focused work and study.

Woodbury's own paintings embrace a lyrical style influenced by French impressionism but distinctly American in its force and vitality. In Ogunquit he encouraged his students to use that style to describe not only the appearance of the landscape, but also their individual response to its unique beauty. Woodbury advised them to "paint in verbs, not nouns" (Culver), reflecting the fact that the Ogunquit landscape was one of motion and activity—from the pounding waves and changing cloudscapes to the human activity of the beaches and wharves. Woodbury also counseled his students on the importance of observation as the underpinning for their art; in fact, in 1923 the summer school was somewhat loftily renamed The Art of Seeing—Woodbury Course in Observation. The school remained in almost continuous operation until Woodbury's death, in 1940.

JSR

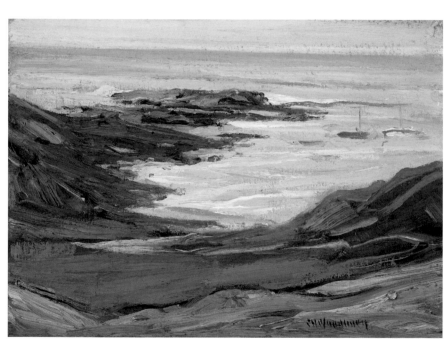

Plate 19

References:

Michael Culver, *Charles H. Woodbury and His Students* (Ogunquit, ME: Ogunquit Museum of American Art, 1998), np.

Trevor J. Fairbrother, *The Bostonians: Painters of an Elegant Age, 1870–1930* (Boston: Museum of Fine Arts, 1986).

Nancy Jarzombek, *Painting in Motion: The Art of Charles Herbert Woodbury (1864–1940)* (Boston: Vose Galleries, 2002).

Joan Loria and Warren A. Seamans, *Earth, Sea and Sky: Charles H. Woodbury, Artist and Teacher, 1864–1940* (Cambridge, MA: MIT Museum, 1988).

Louise Tragard, Patricia E. Hart, and W. L. Copithorne, *A Century of Color, 1886–1986: Ogunquit, Maine's Art Colony* (Ogunquit, ME: Barn Gallery Associates, 1986).

George M. Young, *Force through Delicacy: The Life and Art of Charles H. Woodbury, N.A. (1864–1940)* (Portsmouth, NH: Peter E. Randall, Publisher, 1998).

Plate 20

Gertrude Fiske (1878–1961)

Plate 21
Foggy Ogunquit, circa 1910
Oil on artist's board, 10 x 14 inches
Portland Museum of Art

Plate 22
Silver Maple, Ogunquit, circa 1920
Oil on canvas, 24 x 30 inches
Portland Museum of Art

As a direct descendent of Governor William Bradford of Massachusetts, painter Gertrude Fiske had deep New England roots. After studying at Boston's School of the Museum of Fine Arts, she went on to become a founding member of the Concord Art Association and the Guild of Boston Artists. She also studied under Charles Woodbury at his summer art school in Ogunquit, Maine, and helped to found the Ogunquit Art Association. Although the bulk of her output ultimately was more closely associated with Boston than with Maine, focusing on figure studies and studio interiors, her work in Ogunquit was arguably more innovative, signaling a shift in American landscape painting at the time.

Like Woodbury, Fiske favored a high horizon line, an atmospheric treatment, and a muted, almost tonalist palette for her landscapes and seascapes. In *Foggy Ogunquit,* swaths of lavender, blue, and gray capture the sea in one of its darker moods, emulating Woodbury in its sensitive color scheme and expressive brushwork. But Fiske also developed an interest in pattern—evident in the leaves of the tree in *Silver Maple, Ogunquit*—that distinguished her from her contemporaries. Her paintings give a sense of the array of Ogunquit's iconic landscapes, from honky-tonk amusements to vestiges of a colonial village, from waves crashing on rocks to soft marshlands.

JSR

References:

Trevor J. Fairbrother, *The Bostonians: Painters of an Elegant Age, 1870–1930* (Boston: Museum of Fine Arts, 1986).

Gertrude Fiske (1879–1961), exhibition catalog (Boston: Vose Galleries, 1987).

Erica E. Hirshler, *A Studio of Her Own: Women Artists in Boston, 1870–1940* (Boston: Museum of Fine Arts, 2001).

Phyllis Peet, *American Women of the Etching Revival* (Atlanta, GA: High Museum of Art, 1988).

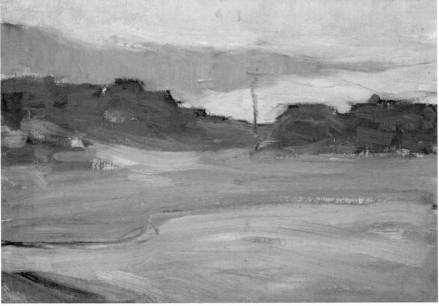

Plate 21

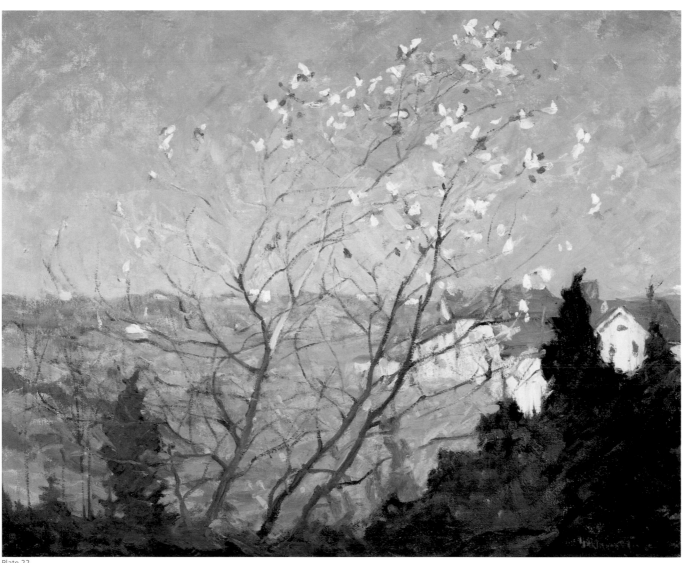

Plate 22

Gaston Longchamps (1894–1986)

Plate 23
Charlie Adams and Bish Young, 1933
Oil on canvas, 48 ⅜ x 36 ⅛ inches
Portland Museum of Art

Among the distinguishing features of the Ogunquit art colony were the fishing shacks that lined Perkins Cove, many of which were converted into artists' studios. This image from a shack's interior conveys that dual role and illustrates the kind of interaction that characterized the relationship between the artists and the "locals." The men pictured are Charlie Adams and Bish Young, Ogunquit fishermen who posed for the students at the art school. Young worked for beer—a six-pack an hour—and was known for his practical jokes.

It is no surprise that Longchamps was drawn more to the people than to the landscapes of Ogunquit—his impressive career as a set designer for ballets and operas at the Metropolitan Opera House in New York was founded upon a passion for the human form. Longchamps's theatrical work as well as his easel paintings were greatly informed by European masters of the subject in the post-impressionist tradition, notably Henri Matisse and Pablo Picasso. His willingness to embrace these avant-garde idioms cemented his role in various anti-academy art movements in the United States, including the American Society of Painters, Sculptors, and Gravers, which was founded in 1919 and included many other artists in Hamilton Easter Field's circle.

JSR

Reference:

Lisa Coffman, "The Rediscovery of Gaston Longchamps," *Bucks County Town & Country Living*, Spring 1997, 70–75, 85–86.

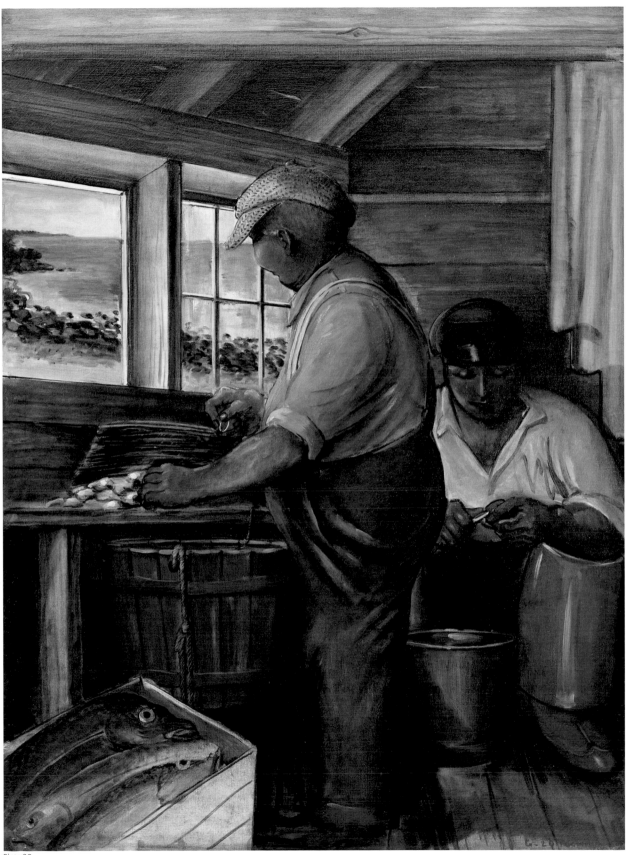

Plate 23

71

Bernard Karfiol (1886–1952)

Plate 24

Bathers, Ogunquit, undated
Oil on canvas, 11 ⅝ x 15 ⅝ inches
Portland Museum of Art

Plate 25

Virginie at Perkins Cove, circa 1920
Oil on canvas, 27 ⁷⁄₁₆ x 36 ³⁄₁₆ inches
Portland Museum of Art

References:

Michael Culver, *Isabel Bishop and Bernard Karfiol: The Realist and the Romantic* (Ogunquit, ME: Ogunquit Museum of American Art, 1995), np.

Jean Paul Slusser, *Bernard Karfiol,* American Artists Series (New York: Whitney Museum of American Art, 1931).

After studying at New York's National Academy of Design, Bernard Karfiol spent several years in Europe mingling with modernist painters and developing his mature vision. His work was included in two groundbreaking exhibitions: the 1904 Salon d'Automne in Paris and the Armory Show in New York in 1913. Intrigued by what he saw at the Armory Show, art impresario Hamilton Easter Field gave Karfiol his first solo exhibition, at the Ardsley Studios, and invited him to Field's newly founded school in Ogunquit. Karfiol summered there for many years as both a student and a teacher. Field said that his work had "a tenderness and an intensity of feeling so rare in American art. . . . It is the expression of an individual, not the expression of an epoch, nor of a community" (Culver).

Embracing a blend of modernism and classicism that was shared by many other artists of the day—Robert Laurent and Yasuo Kuniyoshi were among those in Ogunquit who produced work in this vein as well—Karfiol was interested in the timeless beauty of the human form. Though many of his works depict the classical theme of bathers in a landscape, others demonstrate the Field school's taste for figures painted in the studio. Yet the ocean is still present in this view of the artist's daughter sitting by a window in what may have been one of Ogunquit's many fishing-shacks-turned-artists'-studios. The inside/outside motif had a precedent in both nineteenth-century American portraiture and the work of avant-garde modernists such as Henri Matisse.

JSR

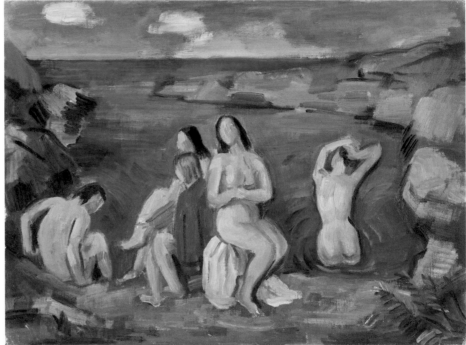

Plate 24

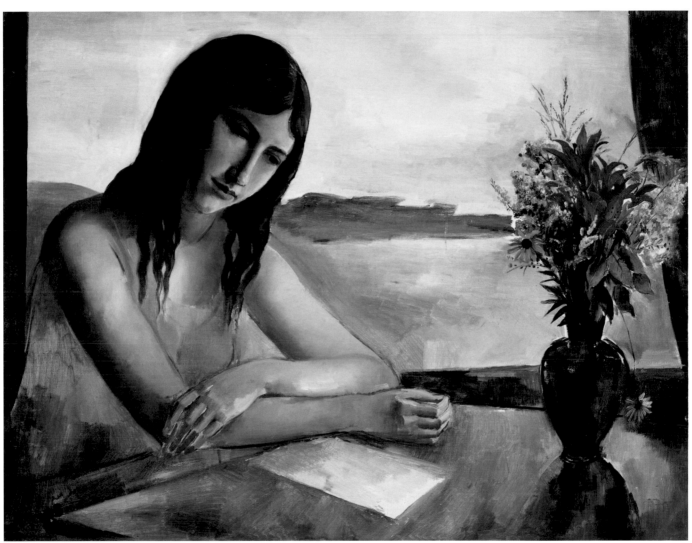

Plate 25

Yasuo Kuniyoshi (1889–1953)

Plate 26

After the Bath, 1923
Oil on canvas, 30 ⅛ x 24 ⅛ inches
Portland Museum of Art

Born in Okayama, Japan, Yasuo Kuniyoshi
had spent several years working as a manual
laborer in the American West before moving
to New York to study painting, in 1910. He
ultimately settled at the Art Students League,
where he became associated with many artists
in the circle of Hamilton Easter Field. Field,
who saw Kuniyoshi's work in the 1917 Society
of Independent Artists exhibition in New York,
would eventually become one of the young
artist's greatest patrons, furnishing him and
his first wife, painter Katherine Schmidt, with
an apartment and studio in Brooklyn in the
winter and at Ogunquit in the summertime.
Kuniyoshi first visited Ogunquit in 1918
and summered there annually through the
mid-1920s, producing an engaging body of
work that reflects the wide array of influence
embraced in the art colony.

Kuniyoshi here uses his flat, cubist style
toward a typically modernist subject—a nude
female figure before a window. Yet the work
also conveys the interest he shared with Field
in the arts of early America. The format
of this painting, originally titled *Captain's
Daughter,* echoes the style of nineteenth-
century American portraits of ship captains.
The framing curtain, the half-length portrait
format, and the sailing vessel viewed out the
window are all fairly literal translations of that
genre, but Kuniyoshi departed from tradition
by wittily replacing the customary octant, or
other navigational tool, with an old-fashioned
curling iron.

JSR

Reference:

Jane Myers and Tom Wolf, *The Shores of a Dream: Yasuo
Kuniyoshi's Early Work in America* (Fort Worth, TX: Amon
Carter Museum, 1996).

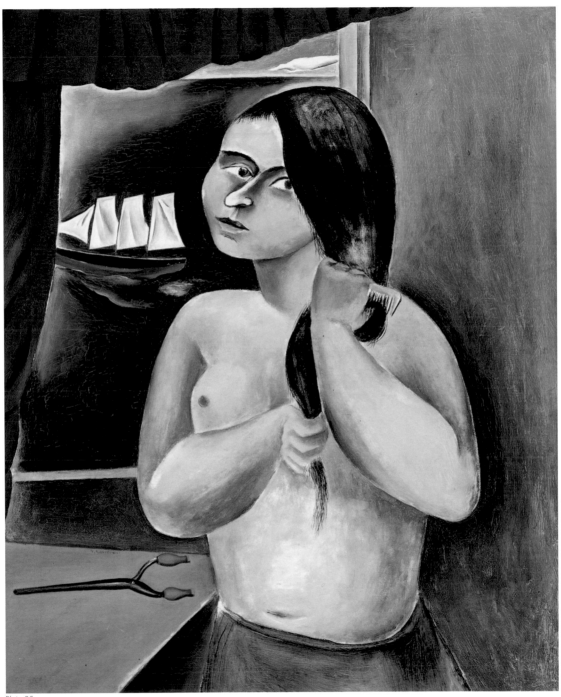

Plate 26

Abraham Walkowitz (1878–1965)

Plate 27

Old Home, Ogunquit, Maine, 1926
Oil on canvas, 26 x 40 ½ inches
Portland Museum of Art

Abraham Walkowitz was part of a community of artists in New York who, in the years between the world wars, attempted to incorporate the latest trends in European art into their own work. This circle included Marsden Hartley, John Marin, and Marguerite and William Zorach, among others, all of whom had or would develop strong connections to the state of Maine. It was perhaps through them—with whom he had also spent time in Provincetown, Massachusetts—that Walkowitz came to visit Ogunquit in the summer of 1926, when this work was painted.

In its parklike, classicized setting and its simplified, iconic use of the human form, *Old Home, Ogunquit,* draws its influence from European postimpressionists like Henri Matisse and Paul Cézanne, artists whose work was also admired and emulated by Americans working in Ogunquit around this time, notably Yasuo Kuniyoshi and Bernard Karfiol. The painting has parallels with Walkowitz's *Bathers* series of the previous decade, in which scholars have observed parallels—through the use of vibrant, primary color and the move toward abstraction—with the work of Wassily Kandinsky, who like Walkowitz, was born in Russia.

JSR

References:

Martica Sawin, *Abraham Walkowitz* (Salt Lake City: Utah Museum of Fine Arts, 1975).

Kent Smith, *Abraham Walkowitz: Figuration, 1895–1945* (Long Beach, CA: Long Beach Museum of Art, 1982).

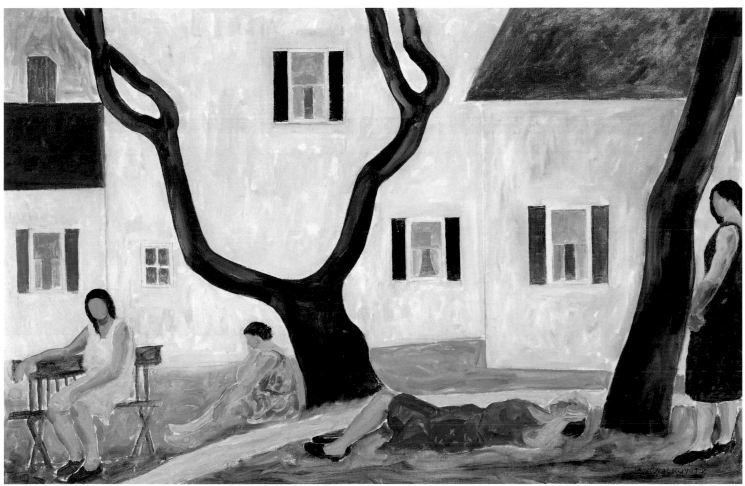

Plate 27

Clarence Chatterton (1880–1973)

Plate 28

Boating with Oliver, Ogunquit, 1929
Oil on canvas, 20 ⅛ x 24 ⅛ inches
Portland Museum of Art

Plate 29

Road to Ogunquit, circa 1940
Oil on Masonite, 24 ⅝ x 31 ½ inches
Portland Museum of Art

Clarence Chatterton was part of the inner circle of modernist painters in Maine. He studied at the New York School of Art under Robert Henri, with classmates such as George Bellows and Edward Hopper, whom he closely befriended. In 1915 Chatterton became Visiting Artist at Vassar College, in Poughkeepsie, New York (Henri and Bellows wrote letters of recommendation), and he arranged for many of his artist friends to exhibit there, cementing the relationship between the college and the city. With his academic year thus occupied, Chatterton sought out opportunities to travel and paint in the summertime. In 1918 and 1919, he accompanied Edward Hopper to Monhegan, marking the beginning of both artists' enduring creative communion with the state of Maine.

Beginning in 1920, Chatterton maintained a summer residence in Ogunquit, where he returned annually for nearly thirty years. There he produced vivid, frank paintings that convey Hopper's influence. The still, sunlit streetscape of *Road to Ogunquit* interprets for a beach setting the New York modernist's interest in light, architecture, and human-created spaces, while *Boating with Oliver*—the title referring to Oliver Tonks, head of the Art Department at Vassar—uses a sparse visual vocabulary to depict the group of figures in the fashions of the day. *Boating with Oliver* dates from a visit that "Tonksie" paid to "Chatty's" Ogunquit summer home in 1929, and the two women are Margaret and Julia Chatterton, the artist's wife and daughter.

JSR

References:

Susan Danly, *Side by Side on Monhegan: The Henri Circle and the American Impressionists* (Monhegan Island, ME: Monhegan Museum, 2004).

The Works of C. K. Chatterton, exhibition catalog (New York: Chapellier Galleries, 1970).

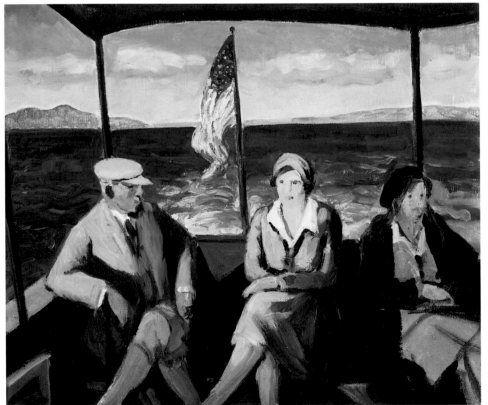

Plate 28

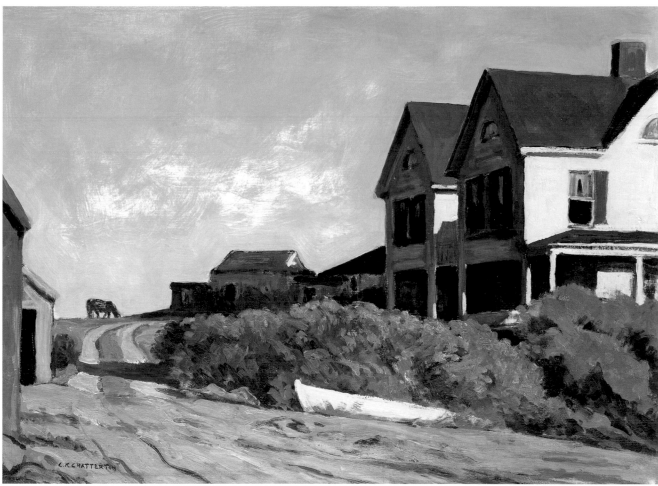

Plate 29

Monhegan Island: "Colony in Rock"

Colony in Rock

On that island that day
fog pressed two cliffs and the ridge
into white-layered barrens.

Gong Buoys, bayberry, paths
blurred into weather.
I was lost in white weather.

Under a wind-grooved ledge
I saw in dark rock a rift
two steps long, half a step wide.

Slivers of wrack and a yew berry
speckled the floor. Eyebright
in still axils had rooted in it
in a scant catch of gravel.
A feather, cormorant or kinglet,
quivered between two spikes
of mica. Scarlet pimpernel
danced its bright stars.

A cumulus of fog hovered
over the crack. The big sea
held back its roar of the far.

Light chipped out a moment there.
In that slant of time
the ledge tilted its floor
to count its gather of colonists
and wayfarers and banners and drums,
and whistled salt-wind songs
of home.

—Reuben Tam

Fig. 25

Sᴇᴛᴛʟᴇᴅ ɪɴ ᴛʜᴇ seventeenth century as one of the first fishing communities in colonial America, Monhegan Island, Maine, began its artistic life some two hundred years later. These two seemingly unrelated occupations—fishing and painting—have been intertwined there ever since. As early as 1875, Sarah Albee, a fisherman's wife and innkeeper, provided rooms and meals to tourists. Later she also purchased part of the island's most imposing Federal-style house, known as the Influence, to house her guests (fig. 25). In the early 1890s the island's first hotel, the Monhegan House, was constructed next to the schoolhouse, and among the growing tourist trade were a number of artists. Samuel Peter Rolt Triscott visited the island with an artist friend from Boston, Sears Gallagher, in 1892.[1] After several years of making summer forays to Monhegan, in 1903 Triscott became the first artist to settle there year-round. Known for his evocative watercolors of the island's daunting scenery (plate 30) as well as its picturesque houses, Triscott also worked as a photographer and frequently hand colored his prints (fig. 26). From the beginning, the role of photography has been especially strong on Monhegan and is one of the distinctive features of artistic practice on the island.

By 1900 there were thirty-three houses and cottages on Monhegan, seven of which belonged to summer people, frequently referred to as "rusticators."[2] One of them was the artist Eric Hudson, who first sailed into Monhegan harbor in 1897, on his way from Bar Harbor to Boston. Immediately attracted by the rugged landscape, Hudson returned the following year and purchased land that had been part

of the old Trefethren Flake Yard, property that belonged to one of the island's old fishing families. Hudson hired William Stanley, a master carpenter and son of the lighthouse keeper, to build a cottage overlooking the harbor in 1898. The artist immediately began producing his signature sailboat scenes, first with an impressionist palette and later in a darker, more romantic style (plate 31). In addition to his paintings, Hudson also produced marine photographs, recording boats and harbor scenes from Venice to Monhegan. His images of local fishermen provide some of the most detailed documentation available of island life at the turn of the century.[3] Some of the posed photographs served as studies for Hudson's paintings, but he took other photographs to capture the hard work entailed in fishing under sail and by hand, the beauty of Monhegan's shores, and the island's architecture—from dilapidated fishing shacks to the new summer cottages springing up in the village. Hudson's set of interior views of the Influence recorded the informal art gallery that his friends, artists Alice Swett and William Claus, set up in a corner of the kitchen in their part of the house.

Many of Monhegan's early artists, such as Charles and Mary Ebert, roomed at the Albee House annex, located in the other half of the Influence. Originally members of the Old Lyme artists' colony in Connecticut, the Eberts helped spread the principles of impressionism to Maine. They first visited Monhegan in 1908 and eventually, in 1914, bought one of the harbor lots from fellow artist George Everett and built their own cottage. They summered there for the remainder of their lives. Their reliance on bright sunlight, pastel hues, and landscape views of the island's headlands and harbor was surely aimed at attracting the attention of summer visitors (plate 32).

Like the Eberts, many of the other impressionist artists working on Monhegan in the teens also had ties to the artists' community at Old Lyme, including Ernest Albert (see plate 16), William Chadwick, William Robinson, Edward Rook (see plate 15), Henry Selden, and Wilson Irvine (plate 33). Despite the picturesque fish house and lobster traps in the foreground of Irvine's view of Swim Beach

and the wharf on Monhegan, the painting emphasizes summertime leisure activities rather than the work-a-day life of the fishermen. Passengers line up to board the schooner *Effort,* which delivered the mail and passengers from Boothbay, as women in bathing bloomers and children play on one of the two small harborside beaches. The fishermen used the island's other beach for gutting fish and hauling out skiffs.

In the first two decades of the twentieth century, the most influential artist who worked on Monhegan was Robert Henri. He encouraged his students and other more established New York artists to visit the island in the summer months as an antidote to the rigors of urban life. A teacher at the New York School of Art and member of a prominent group of artists known as the Ashcan school, Henri specialized in gritty urban subjects. But the island attracted him because of its elemental, natural qualities. He admired the simple but hard life of the fishermen, the rugged landscape, and the power of the sea. In an effort to capture the changing light and atmosphere on the rocky shores of the island, Henri taught his students to follow his practice of making quick outdoor sketches on small panels. He also produced vigorous, almost abstract sketches of the rocks and trees in the island's woods (plates 34 and 35). Eschewing the high-keyed pastel palette of the impressionists, Henri worked up his scenes in more somber, tonal ranges. Instead of sunlit days, he preferred gray, lowery weather that conveyed a sense of the impending forces of nature.

Henri made his first trip to Monhegan in June 1903, in the company of the impressionist painter Edward Willis Redfield, who had invited him to visit his summer home in nearby Boothbay Harbor. After four days of sketching on the island, the two men vowed to come back together later in the summer. Their practice of working side by side laid the informal foundation for the idea of Monhegan as an artists' colony.[4] In August, Henri took the next step by purchasing land on Horn's Hill from the artist-turned-real-estate speculator George Everett. Although he never built a house or a summer art school on the land as he intended, for the next fifteen years Henri

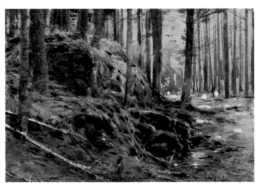

Fig. 26

Fig. 25. Lorimer E. Brackett, oldest house on Monhegan, circa 1930–42, postcard. Collections of Maine Historical Society.

Fig. 26. Samuel Peter Rolt Triscott, *Woods* [Monhegan Island], undated, hand-colored photograph. Portland Museum of Art, Maine. Gift of Earle G. Shettleworth, Jr.

urged his New York students to escape the city and visit the island in the warmer months. [5] The first to follow his advice were Rockwell Kent and Edward Hopper, who began studying with Henri in New York in the fall of 1903. Among Henri's students, Kent established the deepest relationship with the island. He arrived in 1905, bought land on Horn's Hill, and supported himself as a carpenter, eventually building a modest home and studio, as well as a more substantial summer cottage for his mother at Lobster Cove. For the next five years, Kent painted not only the distinctive landscape but scenes of island life, especially that of the fishermen.[6] After his marriage in 1908, Kent managed to paint on the island only in the summer months. But in an effort to ensure a reason for his return, Kent and fellow Henri student Julius Golz established the short-lived Monhegan Summer School of Art in 1910. Following the discovery that year of his extramarital affair with an island woman, Kent abandoned Monhegan, not to return until 1947.[7]

Among Henri's other students who painted on Monhegan in the summer were Randall Davey and George Bellows. They accompanied Henri when he next returned to the island, in 1911, and stayed together at the Monhegan House, where their teacher had previously lodged. In a letter home, Bellows used the term "artists' colony," and it is clear that they traded ideas and reviewed one another's work every day. Although Bellows was already an artist with an established career, while working on Monhegan he began experimenting with new color theories and produced some of the most powerful seascapes of his career. Like Kent, he also viewed the work of the Monhegan fishermen as heroic. The artists' belief in the rugged individualism and physical prowess of life on a remote Maine island further distinguishes their paintings from the more genteel vision of contemporary impressionist artists. Bellows returned to Monhegan two years later, in 1913, to paint with Davey and Leon Kroll, and they were joined by a group of other New York artists, including Homer Boss, Robert Sewell, John McPherson, and Andrew Dasburg—enough to mount a baseball team to compete with the islanders.

With the outbreak of World War I, in 1914, the Monhegan artist colony noticeably diminished, and some, such as Henri, Bellows, and Kroll, moved to the Ogunquit community, preferring the safety and ease of travel to southern Maine. Bellows's last Monhegan scene, made in 1916, was a satirical print of a prayer meeting held in the island church. It featured a portrait of Captain Daniel Stevens, the island's portly lighthouse keeper and resident art connoisseur, whose collection abounded with examples of both the impressionists and the Henri circle. These two groups were also well represented in the first art exhibition held on Monhegan, in 1914, commemorating the three hundredth anniversary of Captain John Smith's landing on the island.

In 1906, to accommodate the growing artist and tourist communities, Frank Pierce, a descendent of one of the island's oldest families, built the Island Inn. Overlooking the wharf, it remains the most imposing structure on the island (seen to left in fig. 25). From that point on, the construction of new summer cottages began to increase at a rapid rate. But the ramshackle fish houses and modest but picturesque older buildings remained the artists' favorite subjects. As early as 1890, these buildings were mentioned in a *New England Magazine* article about the island, illustrated with photographs by Samuel Triscott and sketches by Frank Myrick. Next to a photograph of a fisherman's house surrounded by lobster traps, author A. G. Pettengill noted: "Of the simplest architecture, and often somewhat dilapidated, they are yet exceedingly picturesque by reason of the yellowing touch of age, the artistic grouping of roofs, and the odd bits lying about. To the painter seeking novelties, they are a prize."[8] Monhegan's vernacular architecture certainly held such appeal for the young Edward Hopper, who summered on the island between 1916 and 1919 (plate 36). In addition to numerous oil sketches of Monhegan's dramatic cliffs and colorful rock formations, Hopper also produced two finished etchings, one a scene on the mail boat with passengers bundled up on a windy day. In 1918 he arrived on the island in the company of two other artists, also Henri students, Guy Pène du Bois and Clarence

Chatterton. Chatterton later worked in Ogunquit and, while there, produced a painting of boat passengers, this time enjoying a sunny day in Maine (see plate 28).

During the summer of 1916, George Bellows stayed in Camden, Maine, and he took the opportunity to visit another offshore fishing community, on Matinicus Island. Like Hopper, he too began to experiment with printmaking and created both a lithograph and a painting of the island's busy wharf (plate 37). It was their teacher, Robert Henri, who most likely first drew their attention to the pictorial qualities of these ramshackle structures that perch precariously at the edge of the sea. In Henri's dramatic painting *Storm Tide* (Whitney Museum of American Art), painted from a sketch done on Monhegan in 1903, dark, brooding, clouds and churning waves underscore the fragility of the island's fishing shacks stacked up at the edge of the harbor. A preponderance of Monhegan's early painters and photographers deliberately sought out its high cliffs, mammoth rock formations, and wave-washed shoreline to further convey the power of nature.

Monhegan's primeval forest, known as Cathedral Woods, also caught the attention of Henri and his circle, who explored it in painterly oil sketches and lush pastels. Henri's small study of tangled branches and protruding boulders (see plate 35) echoes Triscott's hand painted photograph of the forest interior (see fig. 26). Most of these woodland scenes, bereft of the human figure, further suggest the primacy of nature over man. Like the painters, photographer Warner Taylor frequently filled his woodland images with dense, dark patterns of intertwined leaves, ferns, and tree trunks, dappled here and there with patches of sunlight (fig. 27). Taylor, an English professor by profession, represented a new artistic force of amateur artists drawn to the island after the end of World War I. Taylor first came to the island in 1913 and eventually built a summer cottage outfitted with a photographic darkroom in 1923. His prints, along with those by his mentor Bertrand Wentworth, a professional photographer, were sold on the island to the growing number of summer visitors. Wentworth was one of several pictorial-

ist photographers, including Frances and Mary Allen and Paul Anderson, who worked on Monhegan in the teens. Like them, he preferred a soft-focus lens and the hazy atmospheric effects of fog and diffused light.

In addition to selling his prints on Monhegan, Warner Taylor also exhibited his work in many of the pictorialist photography salons across the country, including those held at the Portland Museum of Art as late as the 1930s and 1940s. Related by marriage to the Monhegan painter George Fuller, Taylor felt that he was very much part of a wider artistic community.[9] Among his most popular subjects, scenes of waves crashing on the rocky shores of Monhegan became a theme that preoccupied a new generation of artists in the decades following World War II.

The work of Taylor's contemporary George Daniell also bridged the gap between fine art and photography in the 1930s. The young New York artist had attended art classes with Bernard Karfiol in Ogunquit and, in 1933, arrived on Monhegan armed with a sketchbook and a camera. As Daniell remembered the boat ride to the island: "Once I saw the island rising out of the sea I felt I was approaching a foreign country as well as a home."[10] Over the next few summers, he made numerous modernist sketches of the island's architecture, filled with fractured angles and prismatic touches of color. His photographs, taken in the new "straight" style of modernism, eschewed the soft focus of pictorialism in favor of sharpness of form and simple geometries (fig. 28).

As art historian Jessica Nicoll astutely observed in her monograph on the painter Abraham Bogdanove, while the initial art colony on Monhegan was made up of a "constantly changing roster of artists," those working on the island in the 1920s and 1930s "created a more sustained sense of community."[11] Bogdanove, an established mural painter, arrived in 1918 and by 1920 purchased a studio on Horn's Hill that had been used by Henri's student Randall Davey. On Monhegan, Bogdanove's artistic practice began to change dramatically, and eventually he became better known as a marine painter (plate 38). He could often be seen with his portable easel

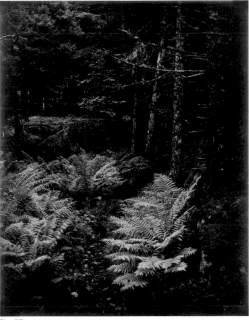
Fig. 27

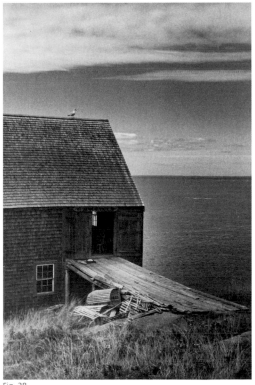
Fig. 28

Fig. 29

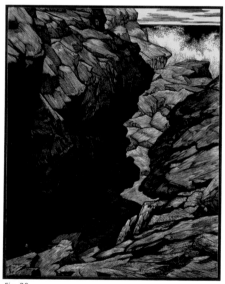

Fig. 30

Fig. 29. G. Herbert Whitney, Abraham Bogdanove painting the Monhegan harbor with Manana Island in the background, 1935, gelatin silver print photograph. Collections of Maine Historical Society.

Fig. 30. Leo Meissner, *Crevasse*, 1934, linocut on wove paper. Portland Museum of Art.

case sitting on the rocks while making plein-air paintings (fig. 29). The vigorous strength of his paint application and use of natural pigments combined to suggest the power of his subject—the force and movement of the sea. On summer evenings, he and his other artist friends often visited at Eric Hudson's home, where they exchanged ideas and critiqued one another's work.

During this period two other artists, Jay Hall Connaway and Andrew Winter, also concentrated on painterly scenes of the island's rugged rocks and the simple forms of its vernacular architecture. Contemporary critics recognized that all three artists—Bogdanove, Connaway, and Winter—were especially influenced by the late seascapes of Winslow Homer, whose reputation as a great American painter was on the rise. After Homer's death, in 1910, numerous exhibitions, catalogs, and articles appeared that singled out Homer's Maine seascapes as the apogee of his career.[12] These dramatic seascapes of bounding waves and rock were painted at Prouts Neck, just south of Portland, which at that time was becoming a well-populated community of summer homes. Filled with shingle-style cottages, Prouts Neck lacked the historic fishing village and remote location of Monhegan. Nonetheless, Homer managed to suggest it was a rugged and barren place where one went to confront the power of the sea.[13] Monhegan's best-known graphic artist of this period, Leo Meissner, must have also been influenced by Homer's late work. The majority of Meissner's Monhegan prints feature deep crevasses, pounding waves, and barren rocks and are devoid of human presence (fig. 30). By way of contrast, his scene of the art colony at Ogunquit depicts a busy harbor filled with tourists and fishermen (see fig. 20).

Jay Connaway first came to Maine after studying art in Paris in the late teens and early 1920s. His dealers Robert Macbeth and Albert Milch, who had also worked with Robert Henri and George Bellows, suggested that Connaway explore the down-east coastline, and his first exhibition in 1923 included numerous Maine seascapes. After more art studies at Pont-Aven, the French art colony in coastal Brittany, Connaway returned home in 1931, at the

beginning of the Great Depression. He and his wife headed for Monhegan because of the active artists' community and inexpensive way of life. In 1939 he established the Connaway Art School, and the following year he bought an arts-and-crafts-style cottage at the top of Horn's Hill, where he lived until 1947.[14] The school attracted artists from across the country, especially in the years following World War II, when the GI Bill provided funding for such studies. Adept at painting scenes of stormy seas and wintry gales (plate 39), Connaway continued to paint in a traditional mode, even though he encouraged his students to move toward abstraction.

The work of Andrew Winter, like Jay Connaway's, frequently received favorable comparison to that of Winslow Homer. Winter may have come to Monhegan as early as the 1920s, and during the 1930s and 1940s he was an active member of several art clubs in New York, where he won numerous national art prizes. Eventually, however, in 1940 Winter left the center of the American art world and settled on Monhegan to live year-round. He and his artist-wife, Mary, thrived on the island, even in the harsh winter months, which seemed to be his favorite time of year (plate 40). Soon after they bought the Alice Brown House on Lighthouse Hill, Andrew built a separate studio, including its furnishings. He painted both in the studio and outdoors, where visitors frequently found him ensconced on the rocks (fig. 31). Winter and his wife lived and worked year-round on the island until his death, in 1958.

The late 1940s also saw the return of Rockwell Kent to Monhegan. Staying in the small cottage that he had built on Horn's Hill in 1906, Kent generally visited in the off-seasons of spring and fall in the years between 1947 and 1953. During that time he completed one of his most haunting late works, *Wreck of the D. T. Sheridan* (plate 41). But in 1953, after the tragic drowning of a guest staying at his house, Kent left the island for good. The woman, Sally Moran, had modeled for Kent, and she disappeared under mysterious circumstances—her body eventually was found washed out to sea. During her brief stay on the island, Moran had become acquainted with

the painter James Fitzgerald, who had bought Kent's studio the previous year. Dismissing the rumors that Fitzgerald was somehow complicit in the woman's death, Kent invited him to visit his home in upstate New York that winter, and eventually in 1958, Fitzgerald acquired the Kent cottage. The two friends corresponded with each other until they both passed away, in 1971.

Like Kent, James Fitzgerald was drawn to the rigors of living in isolation on a remote island. The presence of a summer artists' colony held little appeal to these solitary, and often opinionated, men, but they shared a deep appreciation of the year-round community of fishermen, their families, and the harsh Monhegan landscape. Kent and Fitzgerald had both worked on commercial fishing boats in their youth and understood firsthand the physical effort and danger involved in that occupation. Fitzgerald's powerful portrait of a sturdy Monhegan fisherman, wearing oilskins while cleaning fish on the beach, emphasizes the manual labor involved in fishing and the menace of the seagulls that flock overhead (plate 42). Fitzgerald's subject was Frank Pierce, who like many year-round residents, had several sources of income. In addition to fishing, Pierce was the owner of the Island Inn and the keeper of the fog station on neighboring Manana Island from 1902 to 1916. But it was his more romantic work as a fisherman that drew the attention of photographers and painters alike. Warner Taylor photographed Pierce laboring alongside the watercolorist and printmaker Sears Gallagher during this same period (fig. 32). Fitzgerald, too, was an avid watercolorist, and many of his watercolors are related to his oil paintings, such as the portrait of Pierce. Philip Beam, a noted Winslow Homer scholar, favorably compared Fitzgerald's use of the medium to that of the older artist, noting that the younger artist pushed even further Homer's boldness and simplification of forms.[15]

Many of Fitzgerald's stylistic achievements also relate to his synthesis of Asian philosophies and art techniques. On Monhegan he accumulated an extensive library that included books on Chinese and Japanese painting, Zen Buddhism, Taoism, and the Tibetan Book

of the Dead.[16] Of particular interest here, his monochrome works often utilized black ink and opaque Chinese whitewashes. Among those freely brushed images inspired by Asian painting is his view *Island Inn Reflected*, where the calm waters of Monhegan loosely reflect the architectural forms of the building.

In the decade after World War II, the state of American art, in general, was in great flux. As New York became the center of the contemporary art world and abstract expressionism the dominant form of painting, realistic figurative and landscape works drifted to regionalist practices. The relatively small art colony on Monhegan, already on the edge of the art world, became increasingly marginalized. As art communities in Provincetown and at the eastern end of Long Island rose to prominence, Monhegan seemed all the more quaint and old fashioned. Abstract painters in the 1950s began to use larger canvases so, in practical terms as well, they needed more expansive studio spaces. Although there was now regular boat service to Monhegan, the long drive from New York and the cramped space on the mail boat made travel and transport of paintings to and from the island difficult. Those artists who made the trip in the postwar years fell into two camps: some became lifelong summer visitors, but others made only brief visits to the island, along with stays at other popular art colonies on Cape Ann and Cape Cod, in Massachusetts, or in Woodstock, New York. Abstract painters more frequently received fellowships to the MacDowell Colony in New Hampshire, Black Mountain College in North Carolina, or the Yaddo artists' community in upstate New York.

Among the group of transient artists who visited Monhegan just after the war were two painters whose work straddled the divide between representation and abstraction. De Hirsh Margules was a New York poet and painter who, in the late 1920s, had been inspired by the watercolors of the Maine modernist John Marin. The impact of Marin's work is readily apparent in two images of Monhegan that Margules produced in 1947, when he visited the island. Another New Yorker, Ernest Fiene, may have heard of Monhegan through his early friendship with Robert Henri and

Fig. 31

Fig. 32

Fig. 31. M. Rich, *Finishing Touch*, 1948, gelatin silver print photograph of Andrew Winter painting on the rocks on Monhegan. Portland Museum of Art, Maine. Given in memory of George X. Schwartz.

Fig. 32. Warner Taylor, *Gulls, Frank and Gallagher*, undated, gelatin silver print photograph of Frank Pierce and Sears Gallagher. Portland Museum of Art, Maine. Gift of Lucia Miller.

Leon Kroll, in the teens. Like Margules, Fiene had studied in Paris in the 1920s and produced urban scenes of New York from the 1930s to the 1950s. He was on the faculty of the Art Students League from 1938 to 1964 and for two years, 1950 and 1951, taught at the Ogunquit School of Painting and Sculpture. During his brief summer stays in Maine, Fiene painted at various locations, including Monhegan, where he produced landscapes and still lifes (plate 43).

A second group of New York artists established much stronger ties to the island, becoming summer residents and returning year after year. Murray Hantman, who had studied at the Arts Students League and, like Fiene, worked on mural projects, first came to Monhegan in 1945. Eschewing the more traditional painters on the island, Hantman became friends with Theophile Schneider, an experimental painter who favored Cézanne and other modernists. Although Hantman painted what had become the requisite Monhegan subjects—the lighthouse, fishing boats, and headlands—he reduced their shapes to simple geometry and bold colors (plate 44).[17] Over the course of thirty summers spent on the island, Hantman became friends with a growing number of Monhegan artists who favored abstraction: Henry and Herbert Kallem, Michael Loew, Hans Moller, and the actor-artist Zero Mostel. Hantman's social life also centered around his artist friends, sometimes entertaining them with his piano playing and at other times challenging Loew and Moller to chess games. When Hantman first came to the island, he stayed with Schneider, who owned one side of the Influence. Later he and his wife, the sculptor Jo Levy, rented a cottage whose patterned kitchen walls he captured in colorful shapes. Eventually their living room at the Bright Cottage on Horn's Hill became a central meeting place for many of Monhegan's more progressive painters. Each winter Hantman would return to Nyack, New York, and resume his position at the Brooklyn Museum Art School, where he taught from 1959 to 1979.

Another Monhegan artist with ties to New York was Reuben Tam. As a young art student at the University of Hawaii, Tam first learned about Monhegan Island when he saw reproductions of two Rockwell Kent paintings, one of the cliffs at Black Head. After moving to New York City in 1941, he immersed himself in abstract expressionism, just then beginning to emerge as a major art movement. Tam also did graduate work in art history at Columbia University, where he studied with Meyer Schapiro, one of the first American critics to champion the modernist movement. In 1946 Tam arrived on Monhegan in search of the dramatic seascapes that had so haunted his memory. In addition to his formal studies in art and history, Tam was a naturalist and a poet by inclination. For him, Monhegan inspired more than visual expression. Describing his life on the island, he listed the myriad activities that filled his days: "I paint, I write poems, I grow vegetables, I go rock-hounding and collect rocks, I tend a large garden of perennials, set among rocks, I grow exotic tropical plants indoors under fluorescent light, I star-gaze and follow comets, I hike, explore coastlines and read maps, collect sea shells, study the hybridizing of orchids, gather edible seaweeds, photograph sunsets and storm fronts. I'm a moonwatcher and I wade in tide pools."[18] In 1951 he and his wife, Geraldine, who was also an artist, built a small cottage just across the road from the more imposing summer homes erected at the turn of the century by fellow artists George Everett, Eric Hudson, and the Eberts. His contemporary neighbors included the figurative modernists Henry and Herbert Kallem and Zero Mostel. But ever conscious of his link with Monhegan's past, Tam came to own Rockwell Kent's easel.

Reuben Tam painted abstracted landscapes and seascapes—images drawn from the natural phenomena that he so carefully observed and recorded on his daily hikes across the small island (plate 45). In his work, Monhegan, only one and a half miles long and a half mile wide, seems like an entire universe. From May through October he made copious sketches and small acrylic paintings that would fuel his winter work on larger canvases back in his New York studio. In addition to his own painting, from 1946 to 1974 Tam taught at the Brooklyn Museum Art School. It was there that he encouraged a new wave of abstract painters to visit Monhegan[19]—a "gather

of colonists and wayfarers" who, like Tam, spread their roots "in a scant catch of gravel."

Today Monhegan continues to attract painters, photographers, and printmakers who own summer cottages, rent rooms in the Monhegan House and Island Inn, attend various workshops offered by the island's artists, and vie for a coveted spot in the Monhegan artist residency program—a twenty-year-old summer program that provides housing and studio space. Those who have studios open them on a regular basis and show their work at the Lupine Gallery, centrally located at the crossroad on top of Wharf Hill. The opening of the Monhegan Museum, in 1998, inaugurated an important series of annual exhibitions and publications highlighting the history of Monhegan artists. So in many ways this century-old artist colony has thrived as never before. But as Jamie Wyeth, a former summer resident, so astutely observed in one of the many recent publications about the island's artists, its very success compromises the sense of isolation, natural beauty, and admiration for Maine's maritime traditions that first attracted artists to Monhegan a hundred years ago. [20]

Susan Danly

[1] The first artist to purchase land on Monhegan was George Everett (1865–1926), who built a cottage overlooking the harbor in 1896.

[2] For a full history of the island's buildings, see Ruth Grant Faller, *Monhegan: Her Houses and Her People, 1780–1970* (Melrose, MA: Mainstay Publications, 1995).

[3] For a discussion of Hudson's photographs and paintings, see Earle G. Shettleworth Jr. and W. H. Bunting, *An Eye for the Coast: The Maritime and Monhegan Island Photographs of Eric Hudson* (Gardiner, ME: Tilbury House, 1998).

[4] For a comparative study of the impressionists and the Henri circle on Monhegan, see Susan Danly, *Side by Side on Monhegan: The Henri Circle and the American Impressionists* (Monhegan Island, ME: Monhegan Museum, 2004).

[5] Jessica Nicoll discusses the influence of Henri on his students in detail in *The Allure of the Maine Coast: Robert Henri and His Circle, 1903–1918* (Portland, ME: Portland Museum of Art, 1995).

[6] For a more detailed account of Kent's Monhegan years, see the exhibition catalog *Rockwell Kent on Monhegan* (Monhegan Island, ME: Monhegan Museum, 1998).

[7] Kent managed to spend the summer of 1917 on the island but accomplished little in the way of art; see Jake Milgram Wien, "The Return of Rockwell Kent to Monhegan Island, 1917" in *Rockwell Kent on Monhegan*, 16–19.

[8] A. G. Pettengill, "Monhegan, Historical and Picturesque," *New England Magazine*, September 1898, 77.

[9] For a more complete discussion of Taylor's aesthetic position, see Susan Danly, "'Realistic Pictorialism': The Photographs of Warner Taylor," in *Seeing and Beyond: Essays on 18th- to 21st-Century Art in Honor of Kermit S. Champa*, eds. Deborah J. Johnson and David Ogawa (New York: Peter Lang Publishing, 2005), 361–74; and Taylor's unpublished paper "Photography and Painting" (1946–51), in the Taylor Papers, Monhegan Museum, Monhegan Island, Maine.

[10] George Daniell, "End as Beginning: Reminiscences of Monhegan," unpublished typescript, 1987, np. Artist files, Portland Museum of Art.

[11] Jessica Nicoll, *Abraham Bogdanove, Painter of Maine* (New York: Spanierman Gallery, 1997), 12.

[12] For a chronological Homer bibliography, see Gordon Hendricks, *The Life and Work of Winslow Homer* (New York: Harry N. Abrams, 1979), 330–33. See also Franklin Kelly's essay "Time and Narrative Erased," in *Winslow Homer*, Nicolai Cikovsky and Franklin Kelly (Washington, DC, and New Haven, CT: National Gallery of Art and Yale University Press, 1995), 301–67.

[13] The exhibition catalog *Winslow Homer in the 1890s: Prouts Neck Observed*, David Tatham et al. (New York:

Hudson Hills Press, 1990) discusses in detail Homer's work in Maine.

[14] The house is currently owned by artist Don Stone.

[15] Beam's comments, which appeared in the *Bowdoin Orient* (March 26, 1944), are quoted in *James Fitzgerald*, 2nd ed., Calvin Hennig (Monhegan Island, ME: Fitzgerald Studio, 2002), 63.

[16] For a complete listing of Fitzgerald's library and the marked passages, see Hennig, *James Fitzgerald*, unpaginated appendix.

[17] For the details of Hantman's career, see Jessica Nicoll, *Murray Hantman: From Image to Abstraction* (Portland, ME: Portland Museum of Art, 2005).

[18] Tam as quoted in the exhibition brochure *Reuben Tam: Last Looks at Maine*, Alan Gussow (Rockland, ME: Farnsworth Art Museum, 1996).

[19] Among Tam's students and friends on Monhegan were New York artists Larry Goldsmith, Alan Gussow, Elena Jahn, and Frances Kornbluth.

[20] Preface to Carl Little, *The Art of Monhegan Island* (Camden, ME: Down East Books, 2004), 6–7.

Entries by Jessica Skwire Routhier (JSR), Jeffrey W. Andersen (JWA),
and Susan Danly (SD).

Entries

Monhegan

Samuel Peter Rolt Triscott (1846–1925)

Plate 30
Untitled [View of Monhegan], circa 1918
Watercolor on paper, 11 ⅜ x 9 inches
Portland Museum of Art

In many ways the story of Monhegan as an art colony begins with Samuel Peter Rolt Triscott. Born near Portsmouth, England, Triscott studied at the Royal Institute of Painters in Water Colours, in London. He immigrated to Massachusetts in 1871, at the age of twenty-five, finding work as a civil engineer and surveyor while he continued to paint landscapes. Triscott had become one of Boston's leading watercolorists by the time he first visited Monhegan, in 1892, taking along with him his friend and student, the young Sears Gallagher. So impressed was Triscott with Monhegan's openness and beauty—especially after the urban congestion of Boston—that he made it his full-time home by 1903, months before Robert Henri and his students ever set foot there.

Landscape was as fundamental a subject as ever to Triscott during his time on Monhegan, but over the years his focus would narrow. Instead of the kind of panoramic view he built his reputation on, he ultimately was more interested in studies of waves and cliffs and details of rocks and vegetation, his virtuosic academic style remaining unaffected by the modernist ideas and techniques around him. Triscott was also an accomplished photographer; accommodating a growing tourist industry on Monhegan, he produced elegantly composed black-and-white prints as well as hand-colored postcards. In doing so, he created iconic images of Monhegan's distinctive geological landmarks.

JSR

Reference:

Richard H. Malone and Earle G. Shettleworth Jr., *Rediscovering S. P. Rolt Triscott: Monhegan Artist and Photographer* (Gardiner, ME: Tilbury House Publishers in association with the Monhegan Museum, Maine, 2002).

Plate 30

Eric Hudson (1864–1932)

Plate 31

Manana, undated
Oil on canvas, 28 ⅛ x 34 1/16 inches
Portland Museum of Art

Boston-based Eric Hudson was in the vanguard of artists who painted on Monhegan, first visiting there in 1897, fully six years before Robert Henri made his own initial pioneering visit. He soon built a home on the harbor, where he could have an unimpeded view of the moored boats, which were his favorite subject. Like the boats themselves, Hudson's paintings demonstrate an elegance of construction; light and dark elements are conveyed across the picture surface in a way that is balanced yet animated.

Although he studied at Boston's School of the Museum of Fine Arts, where a polished academic style predominated in the final years of the nineteenth century, Hudson developed an aesthetic that was uniquely his own. His palette of deep yet vivid tones is coupled with a thick, layered application of paint, resulting in a crusted surface that is almost architectural in feel, like the crumbling texture of masonry or pilings emerging from the water. Here, the enclosing presence of Monhegan's geography—the limited expanse of the protected harbor and the looming monolith of Manana in the background—serves to distinguish Hudson's work from that of his contemporaries on the island who reveled in the ocean's expanse.

JSR

References:

Susan Danly, *Side by Side on Monhegan: The Henri Circle and the American Impressionists* (Monhegan Island, ME: Monhegan Museum, 2004).

William B. McCormick, "Eric Hudson—Marine Painter" in *International Studio* 75, no. 299 (March 1922): np.

Earle G. Shettleworth Jr. and W. H. Bunting, *An Eye for the Coast: The Maritime and Monhegan Island Photographs of Eric Hudson* (Gardiner, ME: Tilbury House, 1998).

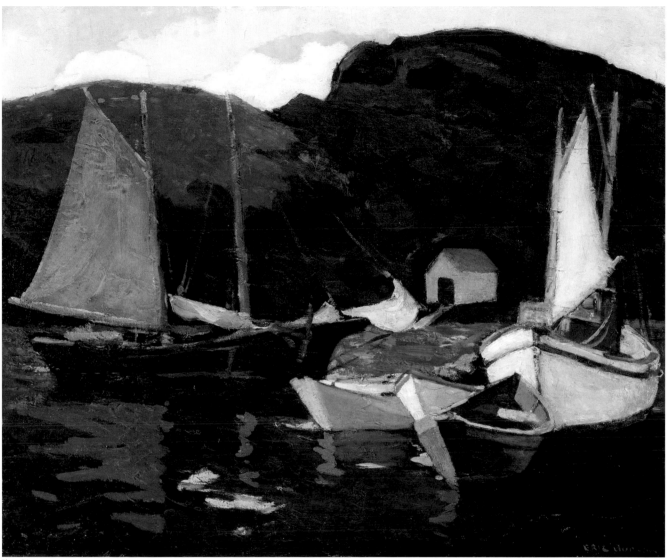

Plate 31

Charles Ebert (1873–1959)

Plate 32

Monhegan Headlands, 1909
Oil on canvas, 30 x 42 inches
Florence Griswold Museum

Charles Ebert had been painting full-time for only a few years before creating *Monhegan Headlands.* A luminous meeting of sea and sky viewed from a windswept bluff, the painting speaks simultaneously of nature's ability to be both peaceful and powerful.

In the 1890s Ebert had studied at the Art Academy of Cincinnati, the Art Students League in New York, and the Académie Julian in Paris. He tried with little success to make a living as a freelance illustrator before landing a steady job as the political cartoonist for *Life* magazine. After moving to Greenwich, Connecticut, in about 1900, Ebert began to study with the impressionist John Henry Twachtman at Cos Cob, and in 1903 Ebert's bride, Mary Roberts, another Twachtman student, convinced him to abandon illustration for landscape painting.

Although Cos Cob, like Old Lyme, was primarily a summer colony, the Eberts usually made summer trips, beginning in 1908, to Maine's Monhegan Island, a place of great appeal to artists, including several from Old Lyme (see, for example, *Monhegan Bay, Maine,* plate 33, by Wilson Henry Irvine). In 1919 the couple moved from Greenwich to Lyme and became active in the Lyme Art Association, but they continued to visit Monhegan and also began to winter in Florida. Such peripatetic comings and goings were not unusual for Old Lyme artists.

JWA

References:

Jane and Will Curtis and Frank Lieberman, *Monhegan: The Artists' Island* (Camden, ME: Down East Books, 1995).

Susan Danly, *Side by Side on Monhegan: The Henri Circle and the American Impressionists* (Monhegan Island, ME: Monhegan Museum, 2004).

Robert P. Gunn and Fenton L. B. Brown, *Charles H. Ebert (1873–1959)* (New London, CT: Lyman Allyn Museum, 1979).

Plate 32

Wilson Henry Irvine (1869–1936)

Plate 33

Monhegan Bay, Maine, circa 1914
Oil on canvas, 36 x 40 inches
Florence Griswold Museum

Monhegan Bay, Maine, portrays a stark change in the economy and daily life of this remote island some ten miles off the Maine coast. Where cod and lobster were once processed, now children and young girls play in the waves. Where ships collected the sea's harvest for transport to urban markets, city dwellers now disembark for a pleasant summer day visiting the quaint island.

The painting is full of telling details. Lobster traps and buoys lay scattered about one of the fish houses, but there is little evidence of current activity. The small beach, formerly used for launching boats and bringing in the catch, has been given over to wading, its bathers unaware of the malodorous air that once hovered there. The dock is packed with colorfully attired passengers coming and going from a day sail. Irvine chronicles Monhegan's newfound role as a tourist destination, something that began in the 1890s, with an eye that invites the viewer to take part. Irvine, who made his home in Lyme, Connecticut, was one of these visitors. Paintings like this helped popularize Monhegan as a rustic summer resort.

JWA

References:

Jane and Will Curtis and Frank Lieberman, *Monhegan: The Artists' Island* (Camden, ME: Down East Books, 1995).

Susan Danly, *Side by Side on Monhegan: The Henri Circle and the American Impressionists* (Monhegan Island, ME: Monhegan Museum, 2004).

Harold Spencer, *Wilson Henry Irvine and the Poetry of Light* (Old Lyme, CT: Florence Griswold Museum, 1998).

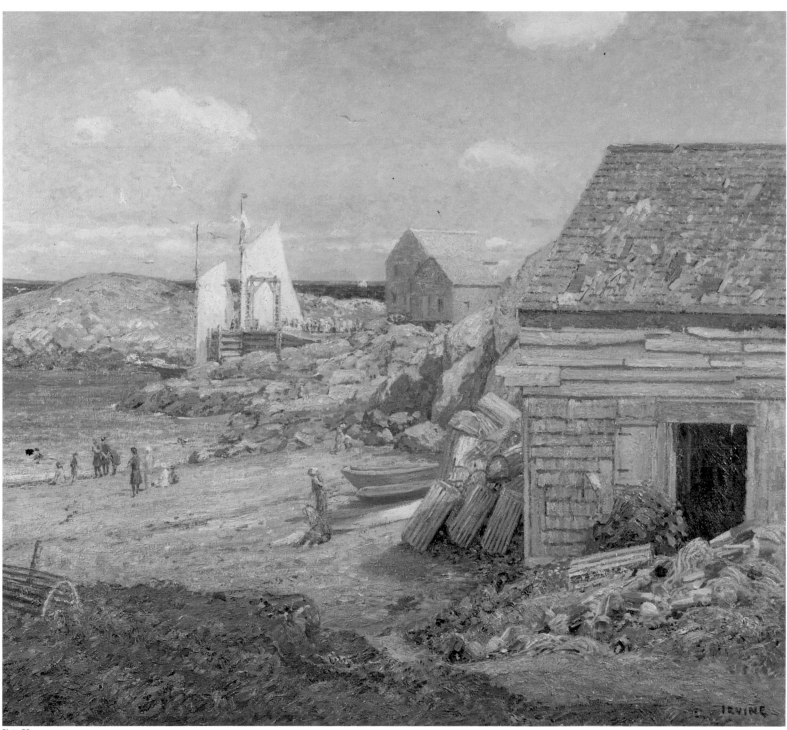

Plate 33

Robert Henri (1865–1929)

Plate 34
Barnacles on Rocks, 1903
Oil on panel, 8 x 10 inches
Portland Museum of Art

Plate 35
The Gray Woods, 1911
Oil on panel, 15 x 11 ¾ inches
Portland Museum of Art

New York painter and teacher Robert Henri considered summer his "great season of work" (Nicoll, 5), in which he retreated to rural settings to concentrate on his own art. Between 1903 and 1918, Monhegan Island was a favored destination. He encouraged his most promising students at the New York School of Art—including Edward Hopper, George Bellows, and Rockwell Kent, among others—to join him there to paint and establish a community of modernist artists.

Henri was driven to marine painting, in part, by his admiration for the paintings of Winslow Homer, observing in them "the whole vastness of the sea, a vastness as impressive and uncontrollable as the sea itself" (Nicoll, 9). To achieve a similarly unified view of the Atlantic in his own modernist idiom, Henri committed himself to painting directly from nature, using small, rigid panels that could easily be carried over Monhegan's uneven turf. He applied his paints vigorously, the architecture of his broad brushstrokes both echoing and articulating the motion of the waves and the structure of the rocks.

For Henri and his students, Maine was a foil to life in New York. They sought simplicity, purity, and honesty as a counterpoint to the complexity of the modern city. They were drawn to Monhegan, in part, because it was conducive to work; the absence of the distractions of everyday life and the stimulus of new surroundings permitted sustained concentration. Monhegan also represented the sort of "primitive" locale to which Henri was drawn throughout his career, finding in them a sense of continuity and tradition, triggering a visceral response to the fundamental nature of things.

JSR

Plate 34

References:

Susan Danly, *Side by Side on Monhegan: The Henri Circle and the American Impressionists* (Monhegan Island, ME: Monhegan Museum, 2004).

Jessica F. Nicoll, *The Allure of the Maine Coast: Robert Henri and His Circle, 1903–1918* (Portland, ME: Portland Museum of Art, 1995).

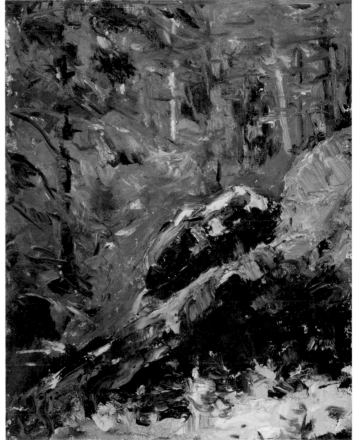

Plate 35

Edward Hopper (1882–1967)

Plate 36

Monhegan Houses, Maine, circa 1916
Oil on panel, 9 x 13 inches
Portland Museum of Art

Like many of those who painted on Monhegan in the early twentieth century, Edward Hopper studied at the New York School of Art under Robert Henri, whom he described as "the most influential teacher I ever had" (Troyen, 37). His first encounters with Maine's landscape were in Ogunquit, where he spent the summers of 1914 and 1915 (Henri and George Bellows were there as well) painting country roads, local buildings, and the rocky coastline. Hopper was to the point about his fondness for Maine, echoing sentiments expressed by many in the years before and since: "Maine is so beautiful and the weather so fine in the summer—that's why I come up here to rest and to paint a little, too" (Nicoll, 28).

In the summer of 1916 and for the next several years, Hopper ventured farther north to Monhegan, one of the few artists to go there during World War I. In Monhegan he encountered a dramatically different Maine landscape from what he had seen and painted in Ogunquit. Nevertheless, he continued to turn his artistic eye toward the built environments that had always drawn his attention, in New York and elsewhere. This oil sketch shows Hopper's characteristic interest in mass rather than the dynamic forces that attracted his colleagues Henri and Bellows. Like them, however, Hopper used small panels such as this one, which he could easily carry all over the island's landscape and townscape, facilitating the practice of painting and inhabiting a scene at the same time. This picture is one of a group of thirty-two small oils of Monhegan by Hopper, twenty-eight of which are in the collection of the Whitney Museum of American Art.

JSR

References:

Gail Levin, *Edward Hopper: The Art and the Artist.* (New York: Whitney Museum of American Art, 1980).

Jessica F. Nicoll, *The Allure of the Maine Coast: Robert Henri and His Circle, 1903–1918* (Portland, ME: Portland Museum of Art, 1995).

Carol Troyen, *Edward Hopper* (Boston: Museum of Fine Arts, 2007).

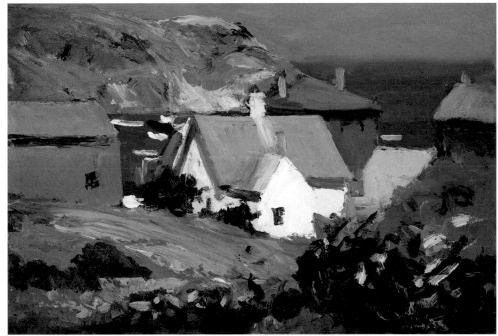

Plate 36

George Bellows (1882–1925)

Plate 37
Matinicus, 1916
Oil on canvas, 32 x 40 inches
Portland Museum of Art

The opportunity for George Bellows to go to Monhegan arose in 1911, when Henri invited him along on his first trip back to the island since 1903. On seeing Monhegan, Bellows wrote to his wife, "This Island is endless in its wonderful variety. It's possessed of enough beauty to supply a continent," adding, "I could stay here and work for years if you were here. This place is an eternal subject" (Nicoll, 17). In fact, he did return to Monhegan for two more summers, until concerns about the island's vulnerability with the onset of World War I kept him and his family on the mainland, first in Ogunquit and then, in 1916, in Camden. From Camden, Bellows set off on his own, exploring the island of Matinicus. During nearly a month there, Bellows used a fish house on the harbor as a studio, producing many views of the working waterfront.

This lush portrayal of the busy wharves of Matinicus is closely related to a drawing (Wiggin Collection, Boston Public Library) and a print of the same year (impression in the collection of the Portland Museum of Art). Although the essential composition remains almost unchanged in all three media, each work conveys a unique vision. With its jangled distortions and adventurous color juxtapositions, this work anticipates the direction that Bellows's painting would take in the last decade of his life.

JSR

References:

Susan Danly, *Side by Side on Monhegan: The Henri Circle and the American Impressionists* (Monhegan Island, ME: Monhegan Museum, 2004).

Trevor J. Fairbrother, *Painting Summer in New England* (New Haven, CT: Yale University Press, 2006).

Jessica F. Nicoll, *The Allure of the Maine Coast: Robert Henri and His Circle, 1903–1918* (Portland, ME: Portland Museum of Art, 1995).

Michael Quick et al., *The Paintings of George Bellows* (Fort Worth, TX: Amon Carter Museum, 1992).

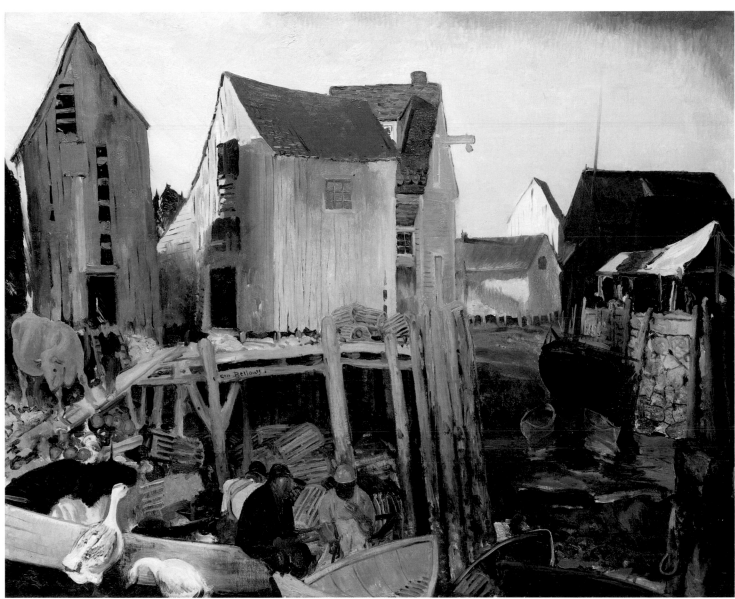

Plate 37

Abraham J. Bogdanove (1886–1946)

Plate 38
Rocky Coast, undated
Oil on canvas mounted on board,
19 ⅞ x 24 ⅛ inches
Portland Museum of Art

Born in Minsk and raised in New York City, Abraham Bogdanove parlayed his artistic training at the Cooper Union, the National Academy of Design, and the Columbia University School of Architecture into a successful career as a mural painter. But soon after his first trip to Maine, in 1915, his interests changed from historical and allegorical scenes to landscape. A visit to Monhegan in 1918 crystallized this new artistic vision, and by the 1920s, views of the island constituted the bulk of Bogdanove's artistic output. The artist visited Monhegan annually until his death, painting extensively and becoming a pillar of the artistic community there.

Compositionally, this painting owes a debt to the bravura Maine seascapes of Winslow Homer and Robert Henri, whose work Bogdanove had seen in New York. The low vantage point, the foreground rocks, and the single animated wave suggest an adherence to time-tested ways of conveying the force of the ocean against rocky shoals. But Bogdanove's distinct interests come through as well—the interlocking planes of the rocks and ocean's surface allude to his architectural background, and the limited, cool palette reveals his interest in the color theories of chemist Maximilian Toch.

JSR

Reference:

Jessica Nicoll, *Abraham J. Bogdanove (1886–1945), Painter of Maine* (New York: Spanierman Gallery, 1997).

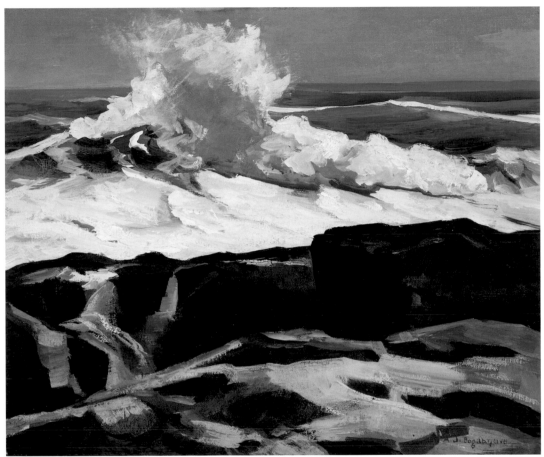

Plate 38

Jay Hall Connaway (1893–1970)

Plate 39

Gull Rock at Headlands, 1948
Oil on canvas board, 18 x 24 inches
Portland Museum of Art

Although the Indiana-born Jay Hall Connaway first visited Maine in the early 1920s, when he painted near Jonesport, his long association with Monhegan did not begin until 1931. In that year Connaway and his new wife returned to the United States after an extended period at the artist's colony in Pont-Aven, France. They sought to re-create some of that communal creative experience by living on Monhegan year-round and founding the Connaway Art School, in 1939. For seventeen years they summered and wintered on the remote island, raising their daughter there and enjoying the varying ambience of community and solitude.

Connaway delighted in painting all aspects of the island—the fisherfolk, the townscape, the island's wooded interior—but his first love was always for the ceaseless interplay between the rocks and the sea. Just as he had tirelessly studied and depicted the craggy shores of France's northern coast, he constantly found new ways to envision the pounding surf of Monhegan. His work is part of the lineage of American seascape painting that includes Winslow Homer and Robert Henri; like them he grappled with the paradox of capturing in a single picture the changing moods of the sea. In Connaway's words, "Whenever I think I know something about painting, I go to the sea where I am properly humbled" (artist's file).

JSR

References:

Artist's file, Portland Museum of Art, Maine; copy of press release issued by the Farnsworth Museum, 1980.

Edward Feit, *Jay Hall Connaway, N.A. 1893–1970* (Boston: Vose Galleries, 1986).

Michael Milkovich, *Jay Connaway, Fifty Years of His Works, 1919–1969: A Retrospective Exhibition* (Binghamton: University Art Gallery, State University of New York, 1969).

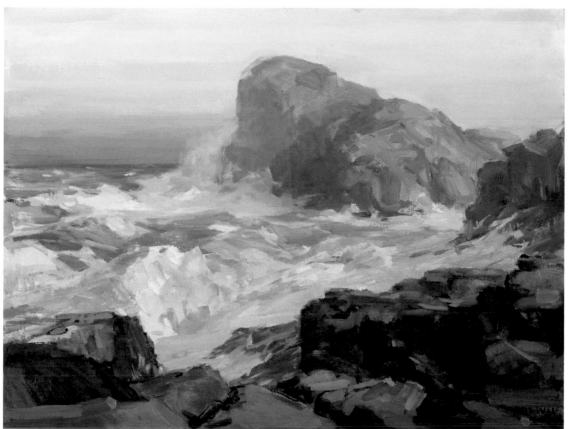

Plate 39

Andrew Winter (1893–1958)

Plate 40

Island Home, Monhegan, 1947
Oil on canvas, 21 ⅞ x 28 inches
Portland Museum of Art

At the age of twenty, Andrew Winter became a merchant marine, initially working on square riggers and eventually on steamboats. In 1921 he decided to become an artist and enrolled at the National Academy of Design. After finishing there in 1925, Winter received a traveling fellowship to study art in Rome and Paris. He then settled in New York City and developed a solid reputation as a seascape and landscape painter during the 1930s and 1940s. The combination of his love for the sea and the arts, no doubt, made Monhegan Island an ideal setting for his work. He frequently rowed around the island in a dory looking for unusual vantage points for his paintings and, at times, worked for the local fishermen. In addition to his paintings and watercolors, Winter built ship models, made wooden carvings, and even wove a tapestry from wool that he dyed himself—a scene of Monhegan harbor based on one of his oils.

Island Home, Monhegan, was awarded the Lempert Prize by the Salmagundi Club in New York and was one of the first Monhegan paintings to enter the permanent collection of the Portland Museum of Art. The hand-carved rustic frame on the painting, made by the artist, further underscores the rugged Monhegan aesthetic developed on the island.

SD

References:

Pamela J. Belanger, *Maine in America: American Art at the Farnsworth Art Museum* (Rockland, ME: Farnsworth Museum, 2000).

Davis Thomas, "Wintering Over on Monhegan," *Down East,* February 1982, 38, 43.

Plate 40

Rockwell Kent (1892–1971)

Plate 41

Wreck of the D. T. Sheridan, circa 1949
Oil on canvas, 27 ⅜ x 43 ⅞ inches
Portland Museum of Art

Rockwell Kent was the first student that Robert Henri encouraged to visit Monhegan, in 1905, when Kent had been studying at the New York School of Art for two years. Kent was as inspired by Monhegan's residents as by its dramatic and varied scenery. As he wrote to Henri, "I love the fishermen here. I never in my life saw such a fine kind hearted set of people. I'd like to be one of them" (Nicoll, 13). With that wish in mind, Kent settled on Monhegan for the better part of the next five years, painting furiously and supporting himself through odd jobs as a carpenter, well driller, and lobster fisherman.

Monhegan was the first of the remote, northern locales that inspired Kent to create some of his most lasting images. His sense of the island's isolation, the self-sufficiency of its residents, and the ever-present battle with natural forces fed his desire to create art that would awaken viewers "to the beauty of our world and to the dignity of man" (Nicoll, 13). As he threw himself into his work, the stylistic influence of his teachers fell away. Kent credited this evolution of his style to the personal maturity that came from living on his own on Monhegan.

Wreck of the D. T. Sheridan dates to Rockwell Kent's return to Monhegan Island after a thirty-year absence. It exemplifies his mature style in its intense palette, crisp forms, and emphatic two-dimensionality. The painting depicts the rusting hull of a steel tugboat that ran aground at Monhegan's Lobster Cove in a dense fog in November 1948. None of the drama of that event is apparent in Kent's image, yet in its skeletal stillness it powerfully conveys humanity's subordination to the forces of nature.

JSR

References:

Edward L. Deci et al., *Rockwell Kent on Monhegan* (Monhegan Island, ME: Monhegan Museum, 1998).

Constance Martin and Richard V. West, *Distant Shores: The Odyssey of Rockwell Kent* (Berkeley: University of California Press in Association with Chameleon Books and the Norman Rockwell Museum at Stockbridge, 2000).

Jessica F. Nicoll, *The Allure of the Maine Coast: Robert Henri and His Circle, 1903–1918* (Portland, ME: Portland Museum of Art, 1995).

Jake Wien, *Rockwell Kent: The Mythic and the Modern* (Portland, ME: Portland Museum of Art, 2005).

Plate 41

James Fitzgerald (1899–1971)

Plate 42
Frank Pierce, circa 1968
Oil on canvas, 24 ⅛ x 30 inches
Portland Museum of Art

James Fitzgerald had achieved moderate success as a painter in Boston and California in the 1940s, when he set up a summer residence on Monhegan. There, he increasingly suffused himself in his painting and in the stunning natural landscape of Monhegan and nearby Baxter State Park. An industrious worker in his studio, Fitzgerald was equally tireless when it came to his daily regimen of standing at the edge of the headlands for hours at a time to study the interplay between the rocks and surf.

Fisherman and owner of the Island Inn, Frank Pierce was another appealing subject for many of the artists and photographers who worked on Monhegan in the middle of the twentieth century. In this portrait Fitzgerald captures the stoic posture of the man at work at the water's edge, beleaguered by diving gulls, with the island of Manana looming in the background.

Fitzgerald produced far fewer oils than watercolors during his lifetime, partly due to the time and expense involved with the slow-drying, costly medium. When he did use oils, however, he became just as involved with his materials, refusing to thin them with turpentine so as not to dilute their vibrancy and resilience. Fitzgerald was also a gilder and made many of his own frames, their simple lines echoing the spare elements of his art.

JSR

References:

By Land and Sea: The Quest of James Fitzgerald (Portland, ME: Portland Museum of Art, 1992).

Calvin Hennig, *James Fitzgerald,* 2nd ed. (Monhegan Island, ME: Fitzgerald Studio, 2002).

Valerie Livingston, *Beyond Description: Abstraction in the Oil Paintings of James Fitzgerald* (Monhegan Island, ME: Monhegan Museum, 2001).

Plate 42

Ernest Fiene (1894–1965)

Plate 43

Lobsterman's Gear No. 1, 1950
Oil on canvas, 28 ⅛ x 22 ⅛ inches
Portland Museum of Art

Ernest Fiene was born in Germany in 1894 and immigrated to New York in 1912. He studied at the National Academy of Design and the Art Students League in New York, where he developed a talent for printmaking under instructors Joseph Pennell and Charles C. Locke. From 1938 to 1964, he served on the faculty of the Art Students League, and through connections there, he became associated with Hamilton Easter Field's Ogunquit School of Painting and Sculpture. Fiene spent two summers in Ogunquit in the 1950s, traveling to and painting in other Maine locations, including Monhegan, during his stays.

JSR

Reference:

Ernest Fiene, *Complete Guide to Oil Painting* (New York: Watson-Guptill Publications, 1964).

Plate 43

Murray Hantman (1904–99)

Plate 44

Blackhead, 1951
Oil on canvas, 20 x 24 inches
Portland Museum of Art

Murray Hantman's artistic development parallels the sea change in American art that began in the years between the world wars and reached an apex with the abstract expressionist movement. Trained at the Detroit Museum of Art School and the Art Students League, Hantman became involved in the mural-painting movement and produced paintings for the Federal Art Project. A visit to Monhegan Island in 1945, however, marked a dynamic shift in Hantman's mode of painting. In an extended series of gouaches (opaque watercolors) of Monhegan's rocks and headlands executed in the late 1940s, he reduced the rocky landscape to its most elemental forms. These works mark the point in his career when he moved from a representational style with a realistic use of color to complete abstractions with a nondescriptive use of color. *Blackhead* is the culmination of Hantman's experiments with light and color to describe the Monhegan landscape. With just three saturated tones, Hantman conveys the distinctive sweep and rise of Monhegan's headlands, showing them as masses of deep blue penetrated by an aqua sea and silhouetted against an orange sky.

After the first few summers on Monhegan, Hantman and his wife, sculptor Jo Levy, began renting a cottage for the season. Eventually the Bright Cottage on Horn's Hill became their seasonal home. Each summer upon their arrival, the couple carefully recorded and deinstalled the traditional paintings of fishing and boating scenes on the walls, replacing them with Hantman's modern paintings.

JSR

Reference:

Jessica Nicoll, *Murray Hantman: From Image to Abstraction* (Portland, ME: Portland Museum of Art, 2005).

Plate 44

Reuben Tam (1916–91)

Plate 45

Waves and Black Ledge, 1949
Oil on canvas, 15 ⅛ x 30 ⅛ inches
Portland Museum of Art

Along with Murray Hantman, Reuben Tam was part of a group of artists who lived in New York and participated fully in the international art scene there in the years after World War II, while spending every summer on Monhegan. Yet unlike Hantman, Tam's affinity with the island began long before he first visited there, in 1946. While still in school in his native Hawaii, he saw reproductions of early Monhegan paintings by Rockwell Kent, and he became fascinated both with Kent's modernism and with the austere geography it depicted. For more than thirty years, Tam divided his time between Monhegan and Brooklyn, where he taught at the Brooklyn Museum Art School. There he encouraged his students to approach landscape with an eye toward geological forces and change over time. Tam's own work dissects the observed world as much as depicts it; his paintings get beyond surface image into the underlying structure of the underwater mountains, which emerge as Monhegan's headlands.

JSR

References:

James Jensen, *Paintings by Reuben Tam* (Honolulu, HI: Laila and Thurston Twigg-Smith Gallery, Contemporary Museum, 1991).

Martica Sawin, "Reuben Tam: Island Paintings," *Arts Magazine*, December 1975, 92–94.

Plate 45

Exhibition Checklist

Artists are listed alphabetically and their works chronologically. Measurements are in inches, height preceding width. Works exhibited at only one venue are marked accordingly: Portland Museum of Art (PMA only) or Florence Griswold Museum (FGM only).

Ernest Albert
United States, 1857–1946
Autumn Day, Connecticut, undated
Oil on canvas, 30 x 32 inches
Florence Griswold Museum. Gift of the Hartford Steam Boiler Inspection and Insurance Company, 2002.1.1

George Bellows
United States, 1882–1925
Matinicus, 1916
Oil on canvas, 32 x 40 inches
Portland Museum of Art, Maine. Bequest of Elizabeth B. Noyce, 1996.38.1

Frank A. Bicknell
United States, 1866–1943
Ogunquit, Maine, undated
Oil on artist's board, 8 x 9 ⅞ inches
Florence Griswold Museum. Gift of Mr. Charles Tyler, 1973.18

Abraham J. Bogdanove
United States (born Russia), 1886–1946
Monhegan Headlands, undated (PMA only)
Watercolor on paper, 12 x 18 inches
Portland Museum of Art, Maine. Gift of Owen W. and Anna H. Wells, 2008.43.9

Rocky Coast, undated
Oil on canvas mounted on board,
19 ⅞ x 24 1/16 inches
Portland Museum of Art, Maine. Gift of Owen W. and Anna H. Wells, 2001.83.3

Matilda Browne
United States, 1869–1947
Saltbox by Moonlight, undated
Oil on canvas, 14 x 10 inches
Florence Griswold Museum. Gift of the Hartford Steam Boiler Inspection and Insurance Company, 2002.1.16

Emil Carlsen
United States (born Denmark), 1853–1932
Godwin's Ridge, Greenwich, Connecticut, 1912
Oil on canvas, 24 x 36 inches
Florence Griswold Museum. Gift of the Hartford Steam Boiler Inspection and Insurance Company, 2002.1.24

William Chadwick
United States (born England), 1879–1962
Laurel, undated
Oil on canvas, 30 x 30 inches
Florence Griswold Museum. Gift of Elizabeth Chadwick O'Connell, 1975.7.4

Clarence Chatterton
United States, 1880–1973
Boating with Oliver, Ogunquit, 1929
Oil on canvas, 20 ⅛ x 24 ⅛ inches
Portland Museum of Art, Maine. Museum purchase with support from Roger and Katherine Woodman, 1996.28

Road to Ogunquit, circa 1940
Oil on Masonite, 24 ⅝ x 31 ½ inches
Portland Museum of Art, Maine. Gift of Pendred E. Noyce, 1997.3.2

Jay Hall Connaway
United States, 1893–1970
Gull Rock at Headlands, 1948
Oil on canvas board, 18 x 24 inches
Portland Museum of Art, Maine. Gift of Owen W. and Anna H. Wells, 2003.43.18

George Daniell
United States, 1911–2002
Fish House and Manana, 1936 (FGM only)
Gelatin silver print photograph,
11 x 13 ⅞ inches
Portland Museum of Art, Maine. Gift of Sally Wallace Rand, 2001.46

Fish House and Sea, 1936 (PMA only)
Gelatin silver print photograph,
13 ¾ x 10 ½ inches
Portland Museum of Art, Maine. Gift of Earle
G. Shettleworth, Jr., 2001.48.2

Group by Fish House, 1936 (PMA only)
Lithographic crayon and crayon on wove
paper, 14 x 11 inches
Portland Museum of Art, Maine. Gift of
George Daniell and the Aucocisco Gallery,
2001.6.2

Woman on Porch with Gulls, 1936 (FGM only)
Lithographic crayon on wove paper,
14 x 10 ¹⁵⁄₁₆ inches
Portland Museum of Art, Maine. Gift of
George Daniell and the Aucocisco Gallery,
2001.6.14

Charles Harold Davis
United States, 1856–1933
Afternoon Clouds, undated
Oil on canvas, 13 x 16 ⅛ inches
Florence Griswold Museum. Gift of the Hart-
ford Steam Boiler Inspection and Insurance
Company, 2002.1.42

Frank Vincent DuMond
United States, 1865–1951
Grassy Hill, 1920
Oil on canvas, 23 ⅝ x 29 ½ inches
Florence Griswold Museum. Gift of Elisabeth
DuMond Perry, 1974.9

Charles Ebert
United States, 1873–1959
Monhegan Headlands, 1909
Oil on canvas, 30 x 42 inches
Florence Griswold Museum. Gift of Miss Elisa-
beth Ebert, 1977.18.1

Reflections, Old Lyme, circa 1919
Oil on canvas, 30 x 30 inches
Florence Griswold Museum. Gift of the Hart-
ford Steam Boiler Inspection and Insurance
Company, 2002.1.53

Untitled [Monhegan Harbor], circa 1925
Oil on canvas, 25 x 30 inches
Portland Museum of Art, Maine. Gift of Peter
H. Davidson, 1983.418

Foot of the Cliffs, circa 1929
Oil on artist's board, 12 x 15 ⅞ inches
Florence Griswold Museum. Gift of Mr. and
Mrs. Robert H. Bartels, 1978.7.10

House on Lyme Street, undated
Oil on canvas, 20 x 25 inches
Florence Griswold Museum. Gift of Miss Elisa-
beth Ebert, 1977.18.10

Water's Edge, undated
Oil on canvas, 19 ⅞ x 27 inches
Florence Griswold Museum. Gift of Miss Elisa-
beth Ebert, 1977.18.13

Ernest Fiene
United States (born Germany), 1894–1965
Lobsterman's Gear No. 1, 1950
Oil on canvas, 28 ⅛ x 22 ⅛ inches
Portland Museum of Art, Maine. Gift of Owen
W. and Anna H. Wells, 2008.43.11

Gertrude Fiske
United States, 1878–1961
Foggy Ogunquit, circa 1910
Oil on artist's board, 10 x 14 inches
Portland Museum of Art, Maine. Bequest of
Elizabeth B. Noyce, 1996.38.9

Silver Maple, Ogunquit, circa 1920
Oil on canvas, 24 x 30 inches
Portland Museum of Art, Maine. Bequest of
Elizabeth B. Noyce, 1996.38.7

Low Tide, undated (PMA only)
Etching on heavy wove paper, 6 ¹¹⁄₁₆ x 8 ¾
inches (plate)
Portland Museum of Art, Maine. Gift of Wil-
liam Greenbaum, 1995.51.1

Untitled [Trees], undated (FGM only)
Etching on wove paper, 4 ¼ x 5 ⅞ inches
(plate)
Portland Museum of Art, Maine. Museum
purchase with support from the Friends of the
Collection, 1995.52.2

James Fitzgerald
United States, 1899–1971
Black Head, Monhegan, circa 1954 (FGM only)
Graphite and watercolor on paper,
31 x 23 inches
Portland Museum of Art, Maine. Gift of Anne
and Edgar Hubert, 1992.9.8

Island Inn Reflected, circa 1964 (PMA only)
Watercolor and gesso on paper,
19 ½ x 22 inches
Portland Museum of Art, Maine. Gift of Anne
and Edgar Hubert, 1992.9.10

Frank Pierce, circa 1968
Oil on canvas, 24 ⅛ x 30 inches
Portland Museum of Art, Maine. Gift of Anne
and Edgar Hubert, 1992.9.11

Walter Griffin
United States, 1861–1935
Summer Haze, Old Lyme, undated
Oil on artist's board, 8 ¹⁄₁₆ x 11 ⅞ inches
Florence Griswold Museum. Gift of the Hart-
ford Steam Boiler Inspection and Insurance
Company, 2002.1.61

Murray Hantman
United States, 1904–99
Blackhead, 1946 (PMA only)
Gouache on paper, 9 x 11 ⅝ inches
Portland Museum of Art, Maine. Bequest of
the artist, 2005.27.2

Whitehead Rocks, 1946 (FGM only)
Gouache on paper, 9 x 12 inches
Portland Museum of Art, Maine. Bequest of
the artist, 2005.27.1

Blackhead, 1951
Oil on canvas, 20 x 24 inches
Portland Museum of Art, Maine. Bequest of
the artist, 2005.27.5

Kitchen, 1953
Oil on canvas, 28 x 19 inches
Portland Museum of Art, Maine. Bequest of
the artist, 2005.27.6

Frederick Childe Hassam
United States, 1859–1935
The Ledges, October in Old Lyme, Connecticut,
1907
Oil on canvas, 18 x 18 inches
Florence Griswold Museum. Gift of the Hart-
ford Steam Boiler Inspection and Insurance
Company, 2002.1.66

News Depot, Cos Cob, 1912
Oil on cigar box lid, 5 ¼ x 8 ¾ inches
Florence Griswold Museum. Gift of the Hart-
ford Steam Boiler Inspection and Insurance
Company, 2002.1.69

Robert Henri
United States, 1865–1929
Barnacles on Rocks, 1903
Oil on panel, 8 x 10 inches
Portland Museum of Art, Maine. Bequest of
Elizabeth B. Noyce, 1996.38.21

The Gray Woods, 1911
Oil on panel, 15 x 11 ¾ inches
Portland Museum of Art, Maine. Gift of Pen-
dred E. Noyce, 1997.3.1

Harry L. Hoffman
United States, 1871–1964
View of the Griswold House, 1908
Oil on pressed board, 16 x 12 inches
Florence Griswold Museum. Gift of the Family
of Mrs. Nancy B. Krieble, 2001.48

Edward Hopper
United States, 1882–1967
Monhegan Houses, Maine, circa 1916
Oil on panel, 9 x 13 inches
Portland Museum of Art, Maine. Museum
purchase with support from the Bernstein
Acquisition Fund, Board Designated Acquisi-
tion Funds, Director's and Curators' Hamill
Acquisition Fund, Friends of the Collection,
Homburger Acquisition Fund, Osher Acquisi-
tion Fund, and an anonymous gift in memory
of the Bears, 2007.1

Eric Hudson
United States, 1864–1932
Monhegan Harbor, circa 1898
Oil on canvas, 12 x 18 inches
Portland Museum of Art, Maine. Gift of Earle
G. Shettleworth, Jr., 2008.31

Manana, undated
Oil on canvas, 28 ⅛ x 34 1/16 inches
Portland Museum of Art, Maine. Gift of Mrs.
Eric Hudson, 1934.5

Wilson Henry Irvine
United States, 1869–1936
Monhegan Bay, Maine, circa 1914
Oil on canvas, 36 x 40 inches
Florence Griswold Museum. Gift of Mr. and
Mrs. George M. Yeager in Honor of the Cen-
tennial, 1999.10

Bernard Karfiol
United States (born Hungary), 1886–1952
Virginie at Perkins Cove, circa 1920
Oil on canvas, 27 7/16 x 36 3/16 inches
Portland Museum of Art, Maine. Museum pur-
chase with support from Roger and Katherine
Woodman, 1983.171

Bathers, Ogunquit, undated
Oil on canvas, 11 ⅝ x 15 ⅝ inches
Portland Museum of Art, Maine. Bequest of
Eileen Barber, 1997.29.1

Rockwell Kent
United States, 1882–1971
Wreck of the D. T. Sheridan, circa 1949
Oil on canvas, 27 ⅜ x 43 ⅞ inches
Portland Museum of Art, Maine. Bequest of
Elizabeth B. Noyce, 1996.38.25

Walt Kuhn
United States, 1877–1949
Lobster Cove, Ogunquit, 1912
Oil on canvas, 20 ⅛ x 24 ⅛ inches
Portland Museum of Art, Maine. Gift of Ellen
Williams, 2000.43

Landscape with Cows, 1922
Oil on canvas, 11 ⅛ x 16 ⅛ inches
Portland Museum of Art, Maine. Bequest of
Elizabeth B. Noyce, 1996.38.28

Yasuo Kuniyoshi
United States (born Japan), 1889–1953
After the Bath, 1923
Oil on canvas, 30 ⅛ x 24 ⅛ inches
Portland Museum of Art, Maine. Hamilton
Easter Field Art Foundation Collection, gift
of Barn Gallery Associates, Inc., Ogunquit,
Maine, 1979.13.26

Robert Laurent
United States (born France), 1890–1970
Reclining Figure, circa 1935
Walnut, 28 1/16 x 53 inches
Portland Museum of Art, Maine. Hamilton Easter Field Art Foundation Collection, gift of Barn Gallery Associates, Inc., Ogunquit, Maine, 1979.13.46

Ernest Lawson
United States (born Nova Scotia), 1873–1939
Connecticut Landscape, circa 1902–4
Oil on canvas, 24 1/8 x 24 1/8 inches
Florence Griswold Museum. Gift of the Hartford Steam Boiler Inspection and Insurance Company, 2002.1.84

Gaston Longchamps
United States, 1894–1986
Charlie Adams and Bish Young, 1933
Oil on canvas, 48 3/8 x 36 1/8 inches
Portland Museum of Art, Maine. Hamilton Easter Field Art Foundation Collection, gift of Barn Gallery Associates, Inc., Ogunquit, Maine, 1979.13.31

Louis Lozowick
United States (born Russia), 1892–1973
Monhegan Island, 1946 (PMA only)
Lithograph, 13 5/16 x 8 13/16 inches
Portland Museum of Art, Maine. Museum purchase, 2009.5.1

Maine Coast, 1946 (FGM only)
Lithograph, 12 x 15 7/8 inches
Portland Museum of Art, Maine. Museum purchase, 2009.5.2

DeHirsh Margules
United States (born Romania), 1899–1965
Lighthouse, 1947 (FGM only)
Watercolor on paper, 22 x 30 inches
Portland Museum of Art, Maine. Gift of Mr. and Mrs. Harrison D. Horblit, 2003.21.2

Untitled [Monhegan Island Harbor], 1947 (PMA only)
Watercolor on paper, 22 x 30 inches
Portland Museum of Art, Maine. Gift of Mr. and Mrs. Harrison D. Horblit, 2003.21.2

Leo Meissner
United States, 1895–1977
Crevasse, 1934 (PMA only)
Linocut on wove paper, 17 9/16 x 13 9/16 inches
Portland Museum of Art, Maine. Museum purchase, 1985.17

Billows of Spray, undated (FGM only)
Wood engraving on wove paper, 9 15/16 x 7 15/16 inches
Portland Museum of Art, Maine. Museum purchase, 1985.36

Fish Beach, Monhegan, undated (FGM only)
Wood engraving on wove paper, 8 1/2 x 10 15/16 inches
Portland Museum of Art, Maine. Museum purchase, 1985.22

Footbridge: Perkins Cove, undated (PMA only)
Wood engraving on wove paper, 8 15/16 x 6 inches
Portland Museum of Art, Maine. Museum purchase, 1985.27

Willard Leroy Metcalf
United States, 1858–1925
An Inlet at Boothbay Harbor, 1904
Oil on canvas, 10 x 14 inches
Florence Griswold Museum. Gift of the Hartford Steam Boiler Inspection and Insurance Company, 2002.1.91

Dogwood Blossoms, 1906
Oil on canvas, 29 x 26 inches
Florence Griswold Museum. Gift of the Hartford Steam Boiler Inspection and Insurance Company, 2002.1.92

Thomas W. Nason
United States, 1889–1971
Maine Islands (Offshore Islands), 1954
Copper engraving on paper, 7 x 12 inches
Florence Griswold Museum. Gift of Mr. Roger Martin, 1991.7

The Lieutenant River, 1964
Wood engraving on paper, 5 5/16 x 10 inches
Florence Griswold Museum. Fletcher Collection Purchase, 1989.14

Leonard Ochtman
United States (born Holland), 1854–1934
Landscape, undated
Oil on canvas, 12 x 16 inches
Florence Griswold Museum. Gift of the Hartford Steam Boiler Inspection and Insurance Company, 2002.1.100

Edward Potthast
United States, 1857–1927
Seascape [Monhegan], undated
Oil on canvas board, 12 x 16 inches
Portland Museum of Art, Maine. Gift of Owen W. and Anna H. Wells, 2003.43.10

Henry Ward Ranger
United States, 1858–1916
Long Point Marsh, 1910
Oil on canvas, 28 x 36 inches
Florence Griswold Museum. Purchase, 1976.5

Edward F. Rook
United States, 1870–1960
Laurel, circa 1910
Oil on canvas, 40 1/4 x 50 1/4 inches
Florence Griswold Museum. Gift of the Hartford Steam Boiler Inspection and Insurance Company, 2002.1.117

Reuben Tam
United States, 1916–91
Waves and Black Ledge, 1949
Oil on canvas, 15 ⅛ x 30 ⅛ inches
Portland Museum of Art, Maine. Gift of Mrs.
Goran F. Holmquist, 1985.220

Samuel Peter Rolt Triscott
United States (born England), 1846–1925
Monhegan Village from Horn's Hill, circa 1895
(PMA only)
Watercolor on paper, 13 ¾ x 19 ¾ inches
Portland Museum of Art, Maine. Gift of Sally
W. Rand, 2002.48

The Pink House, Monhegan Village, 1896 (FGM
only)
Watercolor on paper, 14 ½ x 21 ½ inches
Portland Museum of Art, Maine. Gift of
Sally W. Rand and Earle G. Shettleworth, Jr.,
2002.49

Headland, Monhegan Island, circa 1905
(FGM only)
Watercolor on paper, 11 ⅜ x 9 inches
Portland Museum of Art, Maine. Gift of Earle
G. Shettleworth, Jr., in honor of Sally W. Rand,
1999.12.2

Untitled [View of Monhegan], circa 1918
(PMA only)
Watercolor and gouache on paper mounted
on board, 8 ⅜ x 5 ⁵⁄₁₆ inches
Portland Museum of Art, Maine. Museum
purchase with support from Friends of the
Collection, 2006.26

John Henry Twachtman
United States, 1853–1902
Barnyard, circa 1890–1900
Oil on canvas, 30 ¼ x 25 ⅛ inches
Florence Griswold Museum. Gift of the Hart-
ford Steam Boiler Inspection and Insurance
Company, 2002.1.142

Horseneck Falls, Greenwich, Connecticut, circa
1890–1900
Oil on canvas, 25 ¼ x 25 ¼ inches
Florence Griswold Museum. Gift of the Hart-
ford Steam Boiler Inspection and Insurance
Company, 2002.1.145

Clark Greenwood Voorhees
United States, 1871–1933
December Moonrise, circa 1906
Oil on canvas, 28 ¼ x 36 inches
Florence Griswold Museum. Gift of the Hart-
ford Steam Boiler Inspection and Insurance
Company, 2002.1.150

Abraham Walkowitz
United States (born Russia), 1878–1965
Old Home, Ogunquit, Maine, 1926
Oil on canvas, 26 x 40 ½ inches
Portland Museum of Art, Maine. Bequest of
Elizabeth B. Noyce, 1996.38.51

Everett L. Warner
United States, 1877–1963
The Village Church, circa 1910
Oil on canvas, 32 x 26 inches
Florence Griswold Museum. Gift of Hannah
Coffin Smith in honor of her father, Winthrop
Coffin, 2000.2

Winter on the Lieutenant River, undated
Oil on canvas, 20 x 25 ¾ inches
Florence Griswold Museum. Gift of the Trus-
tees in Honor of Jeffrey Andersen, 2001.47

Andrew Winter
United States (born Estonia), 1893–1958
Island Home, Monhegan, 1947
Oil on canvas, 21 ⅞ x 28 inches
Portland Museum of Art, Maine. Gift of the
Salmagundi Club, 1948.16

Charles Herbert Woodbury
United States, 1864–1940
Perkins Cove, Maine, circa 1900
Oil on board, 10 x 13 ⅞ inches
Portland Museum of Art, Maine. Bequest of
Elizabeth B. Noyce, 1996.38.57

Ogunquit Bath House with Lady and Dog,
circa 1912
Oil on board, 11 ⅞ x 17 inches
Portland Museum of Art, Maine. Bequest of
Elizabeth B. Noyce, 1996.38.56

The Rising Tide, undated
Etching on wove paper, 8 ¾ x 10 ¾ inches
Portland Museum of Art, Maine. Museum
purchase, 1970.4

Selected Bibliography

Andersen, Jeffrey. *Old Lyme: The American Barbizon.* Old Lyme, CT: Florence Griswold Museum, 1982.

Andersen, Jeffrey, and Hildegard Cummings. *The American Artist in Connecticut: The Legacy of the Hartford Steam Boiler Collection.* Old Lyme, CT: Florence Griswold Museum, 2002.

Becker, Jack. *Henry Ward Ranger and the Humanized Landscape.* Old Lyme, CT: Florence Griswold Museum, 1999.

Brown, Dona. *Inventing New England: Regional Tourism in the Nineteenth Century.* Washington, DC: Smithsonian Institution Press, 1995.

Danly, Susan. *Side by Side on Monhegan: The Henri Circle and the American Impressionists.* Monhegan Island, ME: Monhegan Museum, 2004.

Deci, Edward L. *Life on a Remote Fishing Island: 1920–1950.* Monhegan Island, ME: Monhegan Museum, 2007.

Denenberg, Thomas, and Tracie Felker. "The Art Colonies of Old New England." *The Magazine Antiques,* April 1999, 558–65.

Fairbrother, Trevor. *Painting Summer in New England.* New Haven, CT: Yale University Press, 2006.

Giffen, Sarah L., and Kevin D. Murphy, eds., *"A Noble and Dignified Stream": The Piscataqua Region in the Colonial Revival, 1860–1930.* York, ME: Old York Historical Society, 1992.

Grey, Emily. *A Century of Women Artists on Monhegan Island.* Monhegan Island, ME: Monhegan Museum, 2005.

Jacobs, Michael. *The Good and Simple Life: Artist Colonies in Europe and America.* Oxford: Phaidon Press, 1985.

Larkin, Susan G. *The Cos Cob Art Colony: Impressionists on the Connecticut Shore.* New York and New Haven, CT: National Academy of Design and Yale University Press, 2001.

Little, Carl. *The Art of Monhegan Island.* Camden, ME: Down East Books, 2004.

Lübbren, Nina. *Rural Artists' Colonies in Europe, 1870–1910.* New Brunswick, NJ: Rutgers University Press, 2001.

Nicoll, Jessica F. *The Allure of the Maine Coast: Robert Henri and His Circle, 1903–1918.* Portland, ME: Portland Museum of Art, 1995.

———. *Hamilton Easter Field (1873–1922): Pioneering American Modernism.* Portland, ME: Portland Museum of Art, 1994.

Peters, Lisa N. *Visions of Home: American Impressionist Images of Suburban Leisure and Country Comfort.* Carlisle, PA: Trout Gallery, Dickinson College, 1997.

Rosenbaum, Julia B. *Visions of Belonging: New England Art and the Making of American Identity.* Ithaca, NY: Cornell University Press, 2006.

Spencer, Harold, Susan G. Larkin, and Jeffrey Andersen. *Connecticut and American Impressionism.* Storrs, CT: William Benton Museum of Art, 1980.

Tragard, Louise, Patricia E. Hart, and W. L. Copithorne. *A Century of Color, 1886–1986: Ogunquit, Maine's Art Colony.* Ogunquit, ME: Barn Gallery Associates, 1987.

Truettner, William H., and Roger B. Stein, eds. *Picturing Old New England: Image and Memory.* New Haven, CT: Yale University Press, 1999.

Artist Index